Ian G. Manners

Ian G. Manners

Illumination for Calligraphers

The complete guide for the ambitious calligrapher

Marie Lynskey

THORSONS PUBLISHING GROUP

First published 1990

© Marie Lynskey 1990

British Library Cataloguing in Publication Data

Lynskey, Marie

Illumination for calligraphers
1. Calligraphy & manuscript illumination
I. Title
745.6
ISBN 0-7225-2105-7

Published by Thorsons Publishers Limited,
Wellingborough, Northamptonshire, NN8 2RQ, England

Printed in Great Britain by Butler & Tanner Limited, Frome, Somerset

1 3 5 7 9 10 8 6 4 2

Contents

Introduction 7

1 Reviewing the Basics 9
 Pen, Ink and Paper 9
 Posture 11
 The Foundation Hand 15

2 Decorative Borders 24
 Pen-drawn Borders 24
 Painted Borders 36
 Other Border Designs 41

3 Historiated Initials 45
 Clothing 48
 Figures 50
 Surroundings 50
 Diaper 52
 Blackletter 57

4 Gilding 62
 Burnishers 62
 Gold Powder 63
 Gold Leaf 64
 Aluminium Leaf 80

5 Vellum 81
 Types of Vellum 81
 Stretching Vellum 82
 Pouncing Vellum 88
 Removing Errors
 and Blemishes 89

6 Designing Illuminated
 Charts 91
 Layout 91
 Work Order 96
 Choosing Paper 100

7 Maps 102
 Scale 102
 Flourished Capitals 105
 Water and Coastlines 105
 Borders 109
 Illustrations 109
 The Finished Piece 111

8 Celtic Art 113
 Knotwork 114
 Spirals 121
 Key Patterns 124
 Celtic Lettering 126
 Zoomorphics and
 Anthropomorphics 131

9 Alternative Ideas 133
 Writing in Spirals 133
 Wavy Lines 133
 Shapes 135
 Music 135
 Interesting Papers 136
 Different Writing
 Instruments 140

List of Suppliers 142

Index 144

Dedicated to
my parents
Pat and Angela Lynskey
with love.

Introduction

The dictionary defines illumination as 'decoration with gold, silver and brilliant colours' and also 'to light up, make bright'. This book deals with illumination in its broadest sense, including any sort of decoration that can accompany and enhance calligraphy. The range encompasses ancient methods of decorating manuscripts with colour and gold and silver leaf, modern interpretations of these techniques and various illustration processes particularly suitable for lettering.

Obviously, some degree of calligraphic skill is necessary before embarking on complex illumination to accompany it. It is a mistake to spend a lot of time and trouble decorating badly written text that is inferior to its embellishment, so first make sure that your lettering is *worth* illuminating. Many good books are available with instruction for beginners; this book's predecessor, *Creative Calligraphy*, sets out the learning techniques clearly for the beginner.

All the most important stages in learning calligraphy are discussed in Chapter One, and you can use it as a checklist to make sure you haven't slipped into any bad habits since first learning them. Give this chapter a lot of attention and be determined that your lettering will be worthy of the painstaking effort you will need to put into producing beautiful decoration for it.

You can then delve into the exciting ideas and instruction for illuminating your work knowing that you have the ability to produce beautiful results. As the chapters progress you will meet with hands already familiar and also discover some new ones. Each is explained carefully and illustrated with diagrams and photographs so that you can get the most out of your materials and equipment.

Fortunately calligraphy is now growing so fast in popularity that the equipment required is widely available in art shops and stationers — however, for those who have trouble acquiring what they need there are now many mail-order firms specializing in calligraphic materials; these are listed at the end of the book.

Do try to use the recommended items as they really are the

best available and you could find yourself struggling on, wondering why you aren't producing the required results when it is your equipment that is to blame. There are some pens and inks from which even the most experienced calligrapher cannot obtain crisp, delicate strokes. If you want to obtain first-class results do not fall at the first hurdle with inferior equipment — the expense of the most important tools is nothing in comparison to some of the materials required for illumination, so if you are in any doubt about your present instruments get a set of those recommended and you will know that you have the ingredients to produce the best.

The satisfaction to be gained from making illuminated pieces is enormous. You see your piece gradually take shape from the initial sketched roughs, then, as each stage is completed and each new colour added there is a great sense of achievement and even excitement as you see your ideas and expectations become reality.

1 Reviewing the Basics

This book is aimed at the calligraphy student who already has some knowledge of the art-form, perhaps from calligraphy classes or having been self-taught from a beginner's manual. It does not, therefore, cover in detail the learning processes. However, this chapter contains what I would call a sort of 'refresher course' of all the most important rules for producing good lettering so that you can be reminded of the things you have learnt and be sure that you are still doing them correctly.

Different teachers have different methods of putting across the same information, and sometimes different ideas of the correct things to be taught. In calligraphy most agree about the learning process and you will find that although it is very likely that my approach may differ slightly from that which you have already learned, the basic stages are the same as those taught by most tutors who understand the correct methods and principles of the subject.

Pen, Ink and Paper

The most important part of good calligraphy is the equipment. You can be the best calligrapher in the world and not get a good piece of lettering out of a poor quality pen and unsuitable ink. I always use 'William Mitchell' nibs (Fig. 1), having tried many others, and with these inexpensive and widely available nibs you will be able to produce first-class work. Some other foreign makes such as the American 'Speedball' nibs are of an equal standard, but if you are using any other sort you should seriously consider changing to one of these, especially if you have not been happy with your results. Do not expect to get good results from fountain pens with ink cartridges. They may be convenient to use and very suitable for good hand writing but neither the ink nor the nib is the best you can use for calligraphy and you should think only in terms of the best possible if you want to make things of which you can be truly proud.

Your ink should be of the best quality. I often write practice

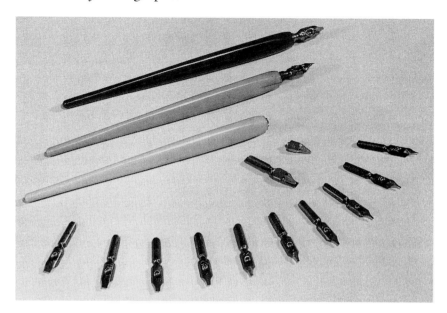

(Fig. 1) '*William Mitchell*' *nibs and pen holders*

pieces and roughs with bottled ink such as 'Osmiroid' or 'Pelikan' calligraphy ink, 'Higgins' or 'Stevens' drawing ink or 'Youth' liquid Chinese ink (Fig. 2), but I *never* use it for an important finished piece of work. Bottled ink has additives that

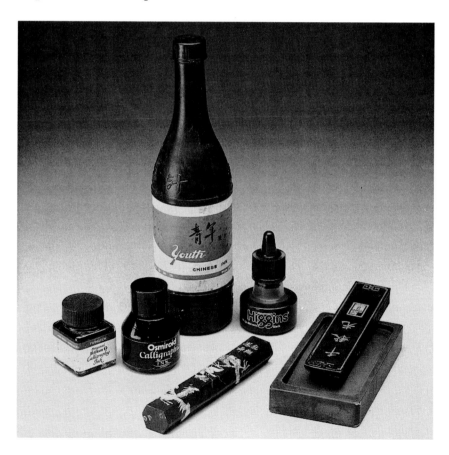

(Fig. 2) *Bottled ink, Chinese ink sticks and slate*

prevent it from rotting, and it is probably these that stop the ink from being quite the right consistency to flow really smoothly from the pen. You will only understand the difference when you have tried the best available, which is Chinese ink in stick form. You buy a stick of ink, usually about an inch wide, five inches long and half an inch thick, and grind it up with water until you have the required thickness. The prepared ink does not keep for more than a day or two, after which time you will be able to smell it going off, so on most occasions it will need to be freshly ground. Small slate vessels are available in which to grind the ink (Fig. 2) and ideally distilled water, available quite cheaply from chemists and garages, should be used so that the ink is free from any chemicals and impurities. A small brush is used to transfer the ink to the nib as shown in Fig. 3.

For lettering in colour use gouache paint rather than coloured bottled inks as the consistency of these is not really suitable for calligraphy. Winsor and Newton Designer's Gouache is sold in tubes in most art shops. It is mixed with water and when used in a pen produces clean, sharp lettering.

A suitable quality paper is the final basic requirement. I have noticed special 'calligraphy practice pads' beginning to be sold in art shops and in many cases this is exactly the inferior quality paper to be avoided, as it is usually thin, shiny stuff that wrinkles when you write on it. In addition it tends to be rather resistant to the ink, preventing it from penetrating the surface sufficiently. This means that the ink sits on the surface, still wet, for longer and the letters are usually rather blotchy. An ordinary pad of cartridge paper such as 'Winsor and Newton' sketching block or 'Goldline' standard 120 gsm cartridge is ideal, or you can buy separate sheets of 120 gsm cartridge paper (gsm stands for grammes per square metre, the weight of the paper or card from which you can judge its thickness). Figure 4 shows three pads of suitable paper, one of which is a pad of coloured sheets. This paper is 'Ingres Vidalon Canson' and there are 11 different colours. It is also available from many art shops in a range of different colours in large single sheets. In Chapter nine more adventurous papers are described.

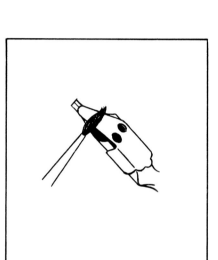

(Fig. 3) Applying ink to the nib with a brush

Posture

A comfortable posture is more conducive than an awkward one, for producing pleasing spontaneous lettering. Every individual is slightly different but basically the posture shown in Fig. 5 is ideal. Your drawing board needs to be sloped at an angle of about 45 degrees and you should sit square to it with your feet on the floor. If you do not have a suitable drawing board you may find yourself suffering unnecessarily, especially your back.

(Fig. 4) Pads of paper

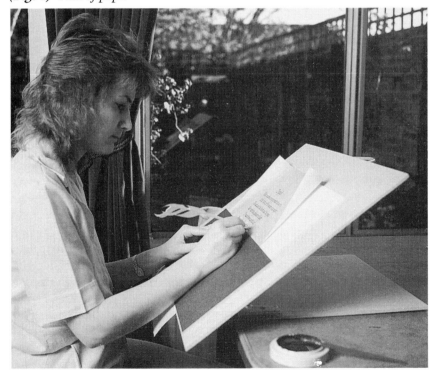

(Fig. 5) Posture

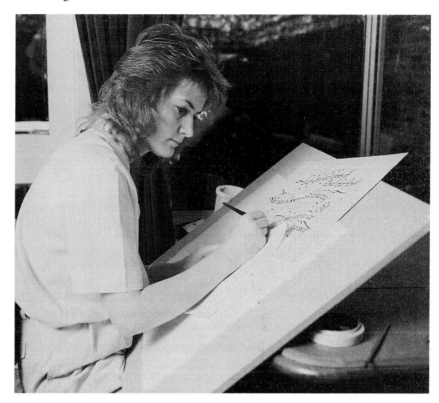

(Fig. 6) Drawing board resting on lap and table

The most common makeshift arrangement is a board balanced on the knees and rested on a table (Fig. 6). I have often had to use this set-up when giving demonstrations where space is limited and I always find it rather uncomfortable. You tend to end up with the board at too shallow a slope as you tire. L. Cornelissen & Son (see list of suppliers on p. 142) sell portable drawing boards that are very suitable and not too expensive, or you can make your own without too much trouble. Make sure you have a couple of sheets of padding, such as blotting paper fixed to your board. The slightly springy surface this will give you is a great advantage over the hardness of the board. Also use a guard sheet so that your hands do not come into contact with the writing surface. Your hands always deposit tiny amounts of grease, etc. on to whatever they touch, so you should always try to keep them from touching your paper, thereby keeping it scrupulously clean.

Hold the pen as shown in Fig. 7 — not too tightly, just firmly enough to give you control of the pen without restricting flexibility in the fingers. For different calligraphic hands the pen meets the paper at different angles, but for the foundation hand, the one most commonly met with, the angle shown in Figs. 8a and b is best. If you understand the use of this angle, the way in which it enables all the letters to be correctly formed, and always

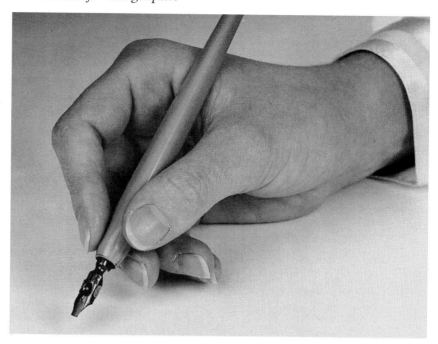

(Fig. 7) Holding the pen correctly

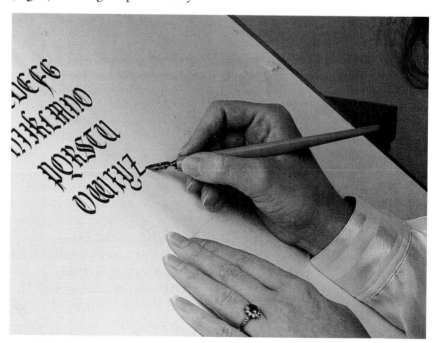

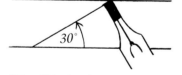

(Fig. 8b) Angle of pen to paper

(Fig. 8a) Angle of pen to paper

use it consistently through the alphabet, then you will find that the other hands and angles sometimes necessary will be understood and correctly written, too.

I never turn the paper at an angle when writing, except when working on something that is not in straight lines parallel to the top edge of the paper. Left-handed calligraphers might find this necessary but it is best avoided if possible. You need to see the

lettering as it will be viewed when finished, not distorted from another angle.

With the knowledge that your equipment is without fault and that you are in a comfortable writing position you can now examine your lettering to see if there is room for improvement.

The Foundation Hand

This is the root of all good calligraphy, if you can write this hand well all the other, more decorative hands will present no real difficulty. The letters are shown in Figs. 9 and 10. They were written with a size $1\frac{1}{2}$ 'Mitchell' nib with the writing lines the standard 5 times the width of the nib. (Fig. 11 shows a useful chart of the line heights or 'x-heights' needed with the different-sized nibs; you can refer to it when planning layouts to tell you how much room each size lettering will occupy.) Write out the alphabet yourself and see how the letters compare with those in the diagrams; if you have some poor-quality letters, use the list below to pinpoint the errors and correct them.

Consistent Letter Size and Shape
The main characteristic of this hand is its 'roundness', in fact it

abcdefghi

jklmnopqr

stuvwxyz

(Fig. 9) Foundation Hand minuscules

ABCDEFGHI

JKLMNOPQ

RSTUVWXYZ

(Fig. 10) Foundation Hand majuscules

is also known by the name 'Roundhand'. The letters should be written with a smooth fluid swinging movement of the pen so that there are no sharply jolting, angular strokes to spoil the appearance of the letters. The *o* is the letter, in this or any alphabet, from which the other letters are gauged, and its width, height, etc. must be repeated in all other letters of a similar shape to give uniformity and consistency to the lettering.

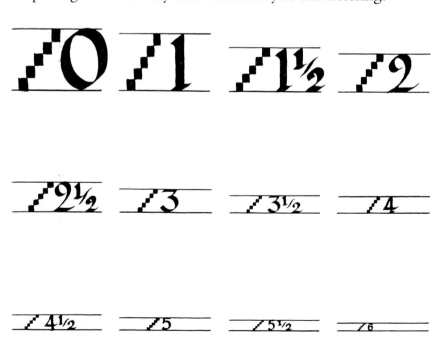

(Fig. 11) Writing line heights (x-heights) for each nib size

The round letters, *a, b, c, d, e, g, o, p* and *q* are all basically an *o* with a bit added or removed.

abcdegopq

The straight stroked letters should also be of equal width and height and the diagonals written with a consistent angle.

fhijklmnrtuy

svwxz

The following examples are taken from pieces of lettering done by some of my calligraphy students and show some of the most common errors.

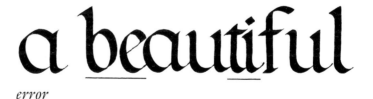

error

The width of each letter is not consistent.

a beautiful

correction

a quick brown

error

The letters overlap or fall short of the writing lines and these errors produce letters too large or too small. If you do this consistently throughout the piece you are writing, it will look all right since you have only altered the height from the normal five-nib widths; but if you do it inconsistently your writing will be dreadfully uneven.

a quick brown

correction

Do not let your verticals slant forward or backward. If necessary write with vertical lines for a while so that you get used to making them straight.

lmn lmn lmn

Some individual letters that often need attention are:

t the cross bar must come *below* the top writing line, not above.

t *not* *t*

s the top and bottom curves must be equal or the top slightly smaller: never make the bottom curve the smaller one.

s *not* *s*

p make sure you do not forget the final stroke of this letter and that it is made up of a proper *o* shape attached to the vertical.

z the middle part of this letter is written with the pen at a different angle so that it will not be too thin, i.e. the nib is turned so that the edge is horizontal.

The ascenders and descenders should all be the same height. You should not have a row of letters like this:

The overall appearance is much neater and more attractive when the letters are the correct height.

Now write out the words in Fig. 12. The lines of text are written with twice the line height between them. If you are not completely happy with the results you may have one of the following points to correct:

Spacing
Unevenly spaced lettering, as shown below, can spoil the appearance of the most beautifully formed letters.

Lord Heygate had a troubled face, his furniture was common place – The sort of Peer who well might pass for someone of the middle class. I do not think you want to hear about this unimportant Peer.

(Fig. 12)

inconsistency

Basically remember that two curved strokes are closest together:

)C

Two straight strokes are the furthest apart:

I I

A curved and a straight stroke have roughly half the distance between them:

IC

Other letters with strokes creating different shapes must be balanced with those either side to look right, e.g.:

kl vo

A well-spaced word:

consistency

As you progress along a line of writing try to picture the letters in groups of three as you make them and match up the spaces between each set. Each time you add another letter you are making another group of three. If you make sure that the middle one appears central each time then the whole word when written should be correct.

Serifs

Make sure that your connecting strokes, or serifs, are only the amount required and not too extravagant. Too little serif is better than too much!

report mirror

incorrect

report mirror

correct

This is a common mistake when first learning, since one tends to get carried away with the attractiveness of the serifed letters after writing very plain letters in the previous stages and there is a

tendency to over-embellish, but calligraphy is often best in its simplest form, with further interest added with separate decoration carefully suited to the lettering.

If you really give all these points your attention and feel satisfied that your lettering complies with them all, then your work will be well worth illuminating and you can proceed with confidence through the rest of this book.

2 *Decorative Borders*

One of the simplest and most effective methods of illuminating a piece of writing is with a decorative border. A good, well-balanced piece of work needs to be carefully planned, and the more time you spend making a trial copy and experimenting with different parts of the piece, the better your final work will be. Borders needn't totally surround the text, often borders on just one or two sides are very attractive. Floral patterns are easiest, and they can be drawn with either the same pen (with perhaps a different-sized nib) as used for the text, or painted with a brush.

Pen-drawn Borders

Begin by writing out the piece you want to illuminate on a large sheet of practice paper in a suitable lettering size and in the shape you wish. Fig. 13 shows a few possible ways of initially arranging a block of text. If it is a piece of verse, the shape will often be dictated by the length of the lines, but you can give the piece extra depth by increasing the amount of space between the lines of writing. If you have a piece of prose, try to arrange the lines so that they are all roughly the same length. Hyphenate words only if it is unavoidable, but do not do so too often or the piece will be tiring to read. Gaps at the ends of lines can always be filled with 'line-fillers' (see p. 57).

For a simple pen-drawn border a straightforward oblong-shaped block of text is needed. If you select what you think will be a suitably sized nib and write out a line or two of the text, you will be able to tell easily if you have chosen a nib size that will give your piece roughly the proportions you want or whether you need to increase or decrease the size of the lettering. Do not worry about the border at this stage, but leave several inches all round the text so that the exact proportions can be calculated later when the design is finished.

The Initial Letter
Borders can be totally separated from the text, being simply a decorative surround or partial surround not attached to the

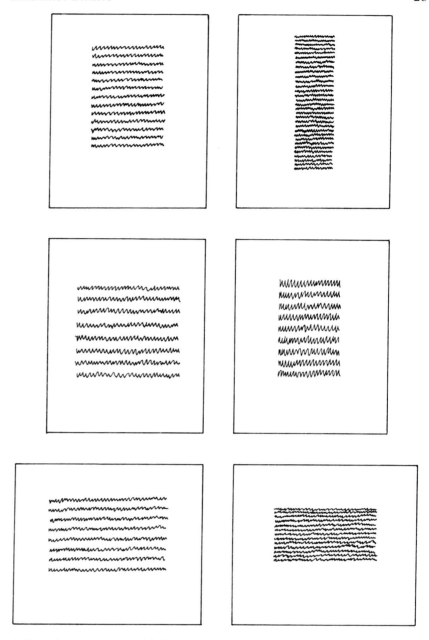

(Fig. 13) Arranging a block of text

lettering, but it is more attractive and extremely suitable with calligraphy to have the border actually *attached* to the text by 'growing' it out of one or two of the letters. The illumination is thereby anchored to the text and looks as if it belongs with it. Initial letters are the obvious ones to choose, and there are a set of letters specially adapted for this use. They are called Versals, and their name derives from exactly their use at the beginning of verses. They are legible, decorative and very adaptable for illumination. They will combine well with most lettering styles.

In historical manuscripts the enlarging and decorating of initial letters was taken to extremes, and entire, highly detailed pictures were included within the letter. These are known as historiated initials and will be dealt with in more detail in Chapter Three.

The initial letter, therefore, forms the starting point for the border and the decoration grows from it along the sides of the

(Fig. 14) *Different amounts of border for a block of text*

text for as far as you wish (Fig. 14). Sketch it in at the corner of the text, not forgetting to cross out the original first letter. Make the letter begin on the same level as one of the first few lines of text (Fig. 15), whichever balances best with the length of your text and the size of the other letters. The curling stems will sprout from convenient parts of the letter and any letter can be adapted for use.

(Fig. 15) *Setting an initial letter into the text*

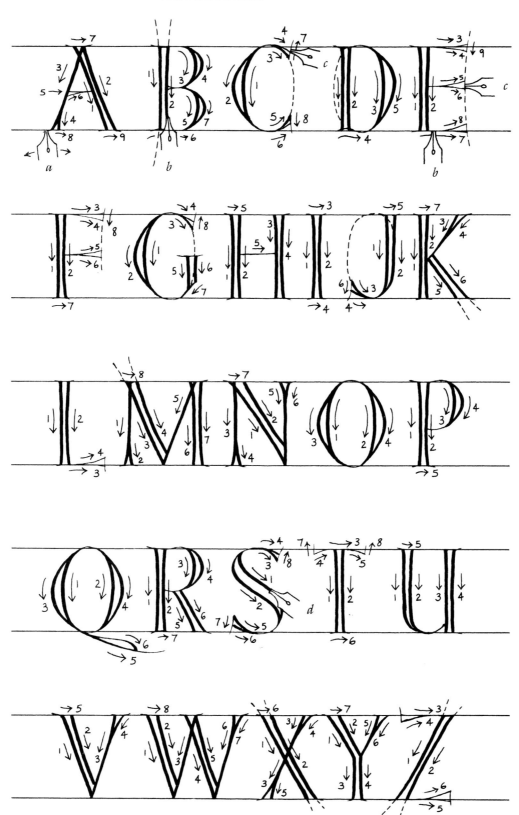

(Fig. 16) *Pen-written versals*

(Fig. 17) Versals with stems for borders

Versals

Pen-written versals are shown in Fig. 16. Normally the centres are filled in as each letter is made — here the centres have been left open to show the construction more clearly. A small-sized nib is used, and it is held so that the edge is parallel to the writing lines, or at a very shallow angle of a few degrees, for most of the strokes (Figs. 16a and b). Versals are compound letters, meaning that parts of each letter are built with more than a single stroke of the pen. The thick parts of the letters are constructed with two strokes, then the centres filled in. With straight parts of letters, such as the first limb of the letter *B*, the lines are made not absolutely parallel but taper together until just over half way down the stroke, then widen out again slightly towards the base (Fig. 16b). This difference has to be very subtle, as over-exaggerated tapering will spoil the simple, strong character of the letters. This tapering applies to all straight double-stroked limbs, including diagonals. When writing rounded letters visualize the whole *O* shape while you are making the piece required, so that each letter will be written with a uniform shape. The thin horizontal strokes are all made slightly curved with a side-to-side swinging motion of the pen (Figs. 16a and c). The *S* is easier to construct if you turn the nib at a slightly steeper angle for the middle strokes (Fig. 16d).

Fig. 17 shows the whole versal alphabet again, with some initial stems to which more can be added. These letters can be very attractively intertwined when required in titles, etc., and as there are several alternatives to some of the letters you can adapt them to your needs. The straightforward versals as shown in Fig. 16 were Roman letters and were very clearly and accurately made. The more curved letters such as the second *E* and *H* in Fig. 17 are known as 'Lombardic'. They are just more exaggerated decorative versions of the simple versals and are interchangeable with them. Their name is derived from their origin in Lombardy where the fashion was for the more ornate.

Forming a Simple Border

When you begin to make the border by adding further stems to the initials, you must make sure that each stem springs out of a previous one in the correct direction, as if it were a growing plant, and in a graceful curve. If you draw the stems in the wrong direction (Fig. 18 – top), you will spoil the pleasing natural effect. Try to evenly space the curls to fill up the space you have, keeping each strand separated from the others and leaving plenty of room to add secondary leaves, flowers, etc., so that the swirling shapes are well defined rather than a tangled confusion of lines.

For a border that runs along the top and down the left-hand side of the text draw in roughly a series of swirling loops along

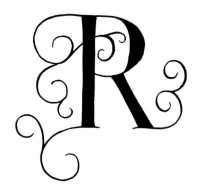

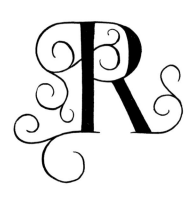

(Fig. 18) *Stems incorrectly (top) and correctly (bottom) formed*

each side to fill up the space (Fig. 19a). Make sure that each stem follows the direction in which a plant might naturally grow, each being formed out of the previous curl and alternating from side to side. When you have an evenly spaced pattern, go over the roughly sketched line making each loop evenly proportioned and with an attractive and pleasing curve. Add further, smaller stems, keeping each part evenly spaced and gradually filling up the gaps (Fig. 19b). Add flowers, buds and finally leaves to complete the pattern (Fig. 19c). Go over the design with a pen so that you can see in which direction you will need to turn it to form the shapes you want (Fig. 19d).

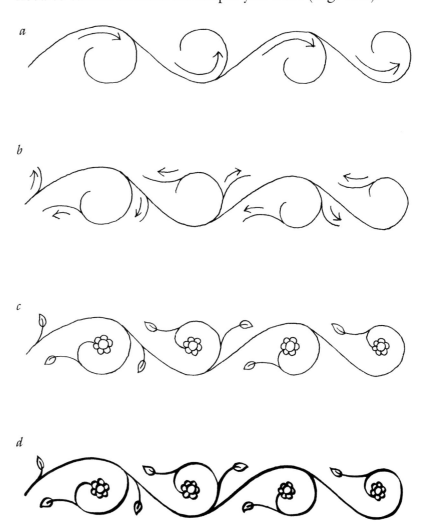

(Fig. 19) Forming a floral border

Margins

Now you can decide on the margins. If you have a given size of paper to fit work on to, you would calculate the margin proportions in the following manner: the standard proportions of the margins of a page of text are normally equal amounts at

the top and sides with a slightly larger margin at the bottom (Fig. 20a). The page height is divided into 16 equal parts, and one part is used as the measure. Two parts are needed for the top and sides and three to four parts at the bottom, depending on where your final line of text will fall.

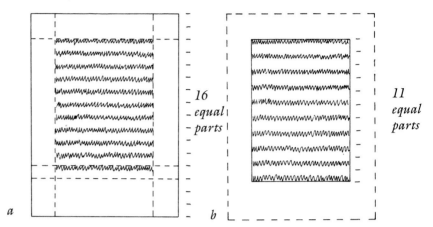

(Fig. 20) *Determining margin proportions*

(Fig. 21) *Determining borders*

When, as is more often the case, you need to add margins to a piece you have already designed, the procedure is very similar. The length of the text is divided into 11 equal parts, then the margins are calculated in the same way, with two of these parts at the top and sides and three at the bottom (Fig. 20b).

If you have designed a border that reaches right along one or more sides of the text, you can treat the whole thing as a block requiring margins (Fig. 21a). If however your border reaches only part of the way round the text, it is sometimes better to treat only the text as the part requiring the margins, leaving the border to spill out into the margins. In these cases a slightly

larger width of margin is better so that there is plenty of room for the border (Fig. 21b).

When the rough design has been completed you can choose suitable paper and colours. You will want the pen to glide over the surface easily when making the curves, so choose a smooth paper as any coarseness will interrupt the strokes and loose fibres may catch on the pen, spoiling the work. Designers' Gouache paint is the best type to use, and Winsor and Newton's range of colours is very extensive. The paint is mixed with water to the consistency of single cream, then applied to the pen with a brush in the same way as ink. Paint flows out of a pen quite well but it does dry on the nib, gradually clogging it up, so every so often wipe it clean with a piece of tissue. Do the lettering first, then trace down the initial letter and border and draw these in with the pen. Try practising the pattern first so that you can draw the strokes fairly quickly, giving them a smoother, flowing appearance. If you draw them too slowly and carefully you are more likely to make shaky, wobbly lines. Fig. 22 shows a simple pen-written and -drawn piece using this method.

Some alternative pen-drawn border patterns are shown in Fig. 23.

(Fig. 22) A simple pen-written and drawn piece

Filigree Pen-work

A very delicate form of letter decoration was used extensively during the 13th century, in which the initial letter was surrounded with a pattern of thin pen strokes running down the border and into the margin. Several letters down the side of a

(Fig. 23) *Pen-drawn border patterns*

page could be linked together to form a continuous border. The letter and its decoration were usually in a bright colour such as red or green to contrast with the black text.

To make the filigree work a size 5 or 6 nib is required. It is worth taking special care to select a smooth paper for this type of work as the small nib is very prone to catching on fibres in the paper during the long flowing strokes required. Do plenty of practice on rough paper before going on to a piece of work, as it takes a while to get used to the small nib and be able to make attractive and graceful strokes.

Make the initial letter first. This can be written either as a compound letter such as a versal with the same nib used for the pattern, or with a large broad nib such as you would use to write an ordinary Blackletter (see p. 57) or perhaps Uncial letter. Build up the pattern around the letter, starting with the parts that actually touch it as shown in Fig. 24.

When you are designing a piece of work you can do these patterns in pencil on the rough to see how the effect will work

(Fig. 24) Building up filigree pen-work pattern around an initial letter

*(Fig. 25) Filigree pen-work decoration, on vellum, size approx.
 16"x12" (406x305mm)*

and to get an even distribution of lines. In Fig. 25 the pattern
was carried down both sides of the lettering from the initial
letters and the title.

 Straight-lined patterns can be used around the initials as in
Fig. 26. It is best to draw the lines free hand, as a ruling pen
gives too regimented an appearance not in character with the
rest of the piece. Other examples of pen-made decoration from
14th- and 15th-century manuscripts are also shown.

Painted Borders

These involve a lot more work than pen-drawn borders. The
most important thing is to get the text and illustration to
balance as it is easy to make the border too overpowering for the
text. As a rough guide, you can afford to be bolder with your
illustration if the lettering itself is large and bold. If you have a

(Fig. 26) *Filigree patterns around initials*

(Fig. 27) Bold and delicate illustration

small-sized, light-textured text, then more delicate illustration is required (Fig. 27). Painted borders can be given a three-dimensional 'modelled' effect with shading and highlighting on the base colours. This will add depth and interest to the work.

Try the design shown in P1.1 as a starting point. The initial sketch follows the same procedure as for the pen-drawn border,

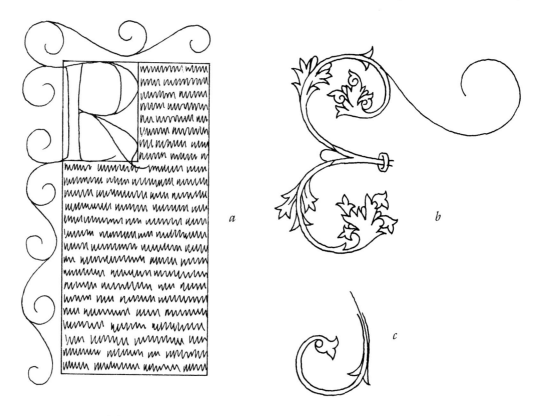

(Fig. 28) Planning a painted border

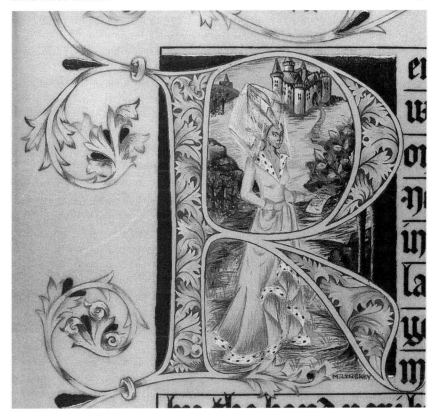

(Fig. 29) Detail of initial letter from Plate 1

fitting a pattern of loops into the available space (Fig. 28a), then the extra detail is added (Fig. 28b). There are two types of termination to each curl and they are alternated along the border up to the final finishing curl (Fig. 28c).

This pattern was adapted from a 13th-century manuscript, and you can use other medieval examples for ideas for future pieces, as this type of illumination was very commonly used. After several attempts you should have enough experience of the process to make up your own designs.

Adding Detail to an Initial

With a more weighty border you will perhaps want to make more of the initial letter. The delicate pattern inside the strokes of the *R* in Fig. 29 is constructed as follows:

On a piece of very thin layout paper or tracing paper draw your letter to the correct size (Fig. 30a). Give it an inside border of about 1–2mm from the sides depending on the letters' height (Fig. 20b). The pattern is a repeated series of curling leaves derived from a similar one on a medieval manuscript. Gradually pencil it in with the aid of Fig. 30c. The corners and narrow points need to be carefully worked out to give neat terminations to each leaf.

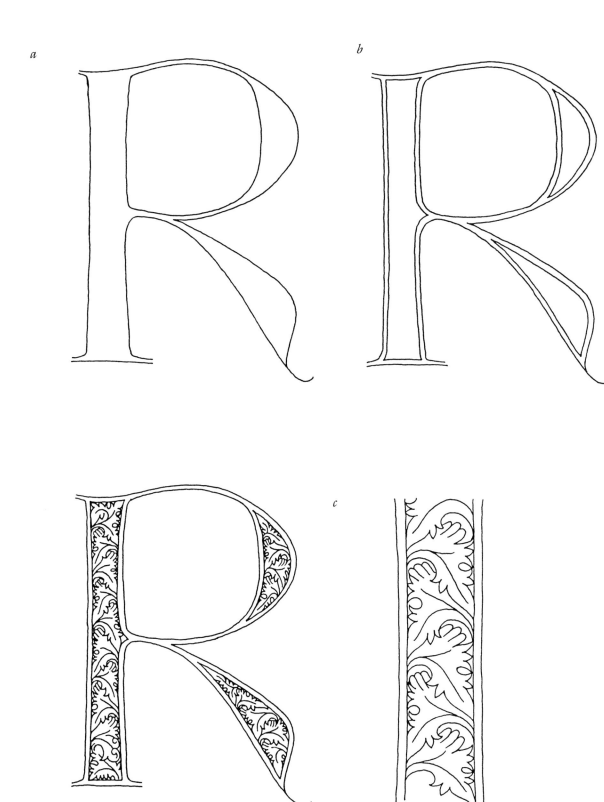

(Fig. 30) Adding detail to an initial letter

After writing the accompanying text, trace the outline into place on the work. Paint the whole letter with a pale shade of the chosen colour (this is referred to as the base colour). Fix the central pattern over the letter and attach it with some masking tape so that it will not move when you trace the pattern on to the work. Use a piece of tracing down paper for this (see list of suppliers), or you can use the more lengthy process of drawing over the back of the pattern with a pencil, then turning it back again and drawing from the front.

The pattern is built up with several layers of progressively darker shades of the base colour (Fig. 31) and finally highlighted with white. Add a little of the full-strength colour to some of the base colour for each stage. It is a good idea to retain some of the base colour, as you might wish to repaint some part of the design this colour if you overdo some of the darker shades, or accidentally cover up a part you want to keep as background.

Other Border Designs

Figs. 32 and 33 show simplified versions of border patterns from medieval manuscripts, which you can experiment with. Fig. 32 the ivy leaf stems curling out of a thin, linear border, is very commonly seen. Sketch the basic shape with the initial letter and guidelines for the leaved stems as shown below then work in the detail (Fig. 34a). A very small nib or a mapping pen

(Fig. 31) Building up detail within a letter

(Fig. 32)

(Fig. 33)

(Fig. 34)

is used for drawing in the outline with black ink. Gold leaf is usually added very liberally, then the colours are painted in.

Fig. 33 is also drawn in ink with a very thin nib. Again, start with the basic outline and gradually add the detail (fig. 34b). The thin strands remain black while the ends of each and the wavy leaves have a touch of green added. Gold has been used for the centre dots of these stems, the outside line of the double straight line, and some other parts of the corner pieces and initial. Blue, green and red have also been added to the initial, the corners, and the larger flowers interspersed along each side.

The border design in the top picture on Pl. 2 was from a manuscript belonging to an Essex parish church in the early 15th century. The original initial was a *D* but the design within it was easily adapted for the *L* that was required here. Pl. 3 is a reconstruction of a page from the Bedford Psalter showing the sorts of colours used in pieces of this type. These are just two examples of the many beautiful designs to be found in books and museums of medieval illumination all over the country, so you need never be short of ideas for creating new pieces.

3 Historiated Initials

Historiated initials are enlarged letters, usually found at the beginning of a page, verse or paragraph. The letters are filled with figures and animals and are usually contained within a box connecting the letter to the border decoration. The lettering style most frequently used in conjunction with historiated initials was Blackletter (see Figs 59 and 61 on pages 58 and 60). This type of lettering is described fully later in this chapter.

Historiated initials usually describe a scene from the text. Fig. 35 for instance, shows the scribe Ezechiel standing to receive a message from God, then seated at his work transcribing the message. The initial is part of the Lambeth Bible, written in the mid-12th century. This is a familiar type of illustration, as medieval scribes seemed to enjoy representing themselves in their work.

Many historiated initials contain religious scenes. These can

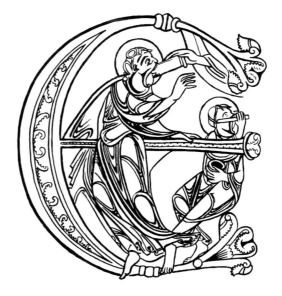

(Fig. 35) 12th-century historiated 'E'

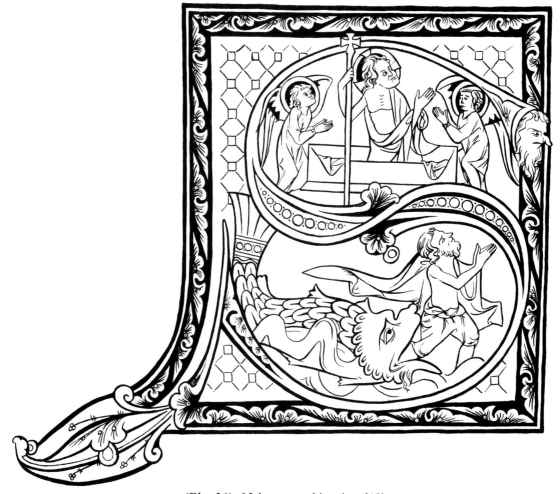

(Fig. 36) *13th-century historiated* 'S'

be extremely complex, containing great detail and much gold leaf. In Fig. 36, the upper part of the letter *S* shows the Resurrection and the lower half Jonah and the whale. The letter is from the York Psalter, written *circa* 1250–60. Rich men and women would commission books showing themselves in important ceremonies, at feasts or tournaments or in a battle. Herbals and Bestiaries were also written with illuminated illustrations.

Initials can vary greatly in size in relation to the text they accompany, sometimes occupying a whole page. At times they were widened out of their normal proportions to give room for the pictures painted within them or to fill the page space better. Fig. 37 shows sketches of layouts incorporating illuminated initials found on 12th- to 14th-century manuscripts. Example (a) was very frequently used, with the large space at the top holding an illuminated picture; the style of these pictures would

(Fig. 37) *Layouts incorporating illuminated initials from 12th- to 14th-century manuscripts*

follow that of the letter decoration. Richly decorated pages in manuscript books were usually followed by several plainer pages, although some of the more illustrious books contain page after page of rich illumination.

When designing the contents of an initial you should bear in mind the various parts that will make up the picture and the sort of treatment each can be given to impart a suitably medieval character.

Clothing

The figures and animals used in initials are often highly stylized. Clothing is represented with many deep folds, as shown on the scribe in Fig. 35. This technique is very effective, based as it is on natural folds: if you drape a piece of silky material over something you will see how it falls into folds very like those in the example. The folds radiate away from the point where the cloth touches the object over which it is draped, and only change direction when the cloth touches another part of that or some other object. This is a useful point to remember when depicting cloth — always imagine an object beneath it and the way the cloth would naturally fall. You can even rig up a piece of cloth in the way you wish to paint it and use it as a model for your picture.

Medieval costume is very interesting, and miniatures and historiated initials show the different types of clothing worn by rich and poor people. In your local libraries you will usually find lots of useful books which can provide further reference material for your pictures. Bright colours were used for clothes, and even simply dressed poor people will be shown wearing bright blues and reds. The clothes on religious figures were usually simply cut, and are represented in these illustrations with an abundance of flowing folds of cloth draped over the figure and belted at the waist. Noblemen and -women are shown in more interesting garments, the ladies in tight bodiced gowns with long flowing skirts, the men in an array of styles, from the dashing short pleated doublet and hose to elaborately draped tunics and cloaks. The cloth is often richly embroidered with patterns and fur-lined or -edged. Headgear was very frequently worn, and during the 15th century reached fantastic proportions for men as well as women, culminating for the ladies in great winged and veiled creations which must have been very cumbersome to wear (Fig. 38).

Poem in Blackletter with decorative border and historiated initial, size 13 × 8 in (330 × 204 mm)

Miniature on vellum with raised gilding, size 7 × 4 in
(178 × 102 mm)

alas that spring should

vanish with the rose

that youths sweet-scented

manuscript should close

the nightingale that in the

branches sang

ah whence and whither

flown again who knows

Persian-style miniature, size 3¹/₂ × 3 in
(89 × 76 mm)

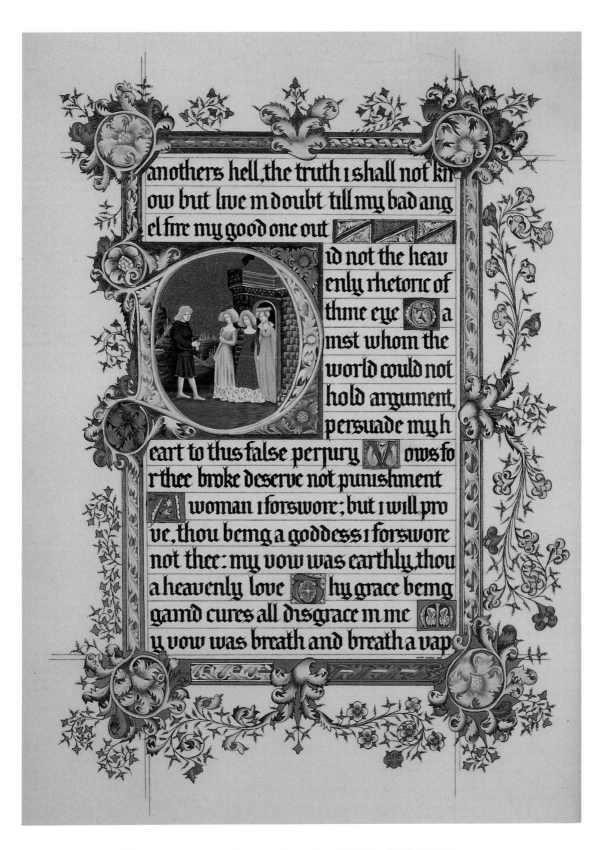

anothers hell, the truth i shall not kn
ow but live in doubt till my bad ang
el fire my good one out

id not the heav
enly rhetoric of
thine eye a
inst whom the
world could not
hold argument,
persuade my h
eart to this false perjury ows fo
r thee broke deserve not punishment
woman i forswore; but i will pro
ve, thou being a goddess i forswore
not thee: my vow was earthly, thou
a heavenly love hy grace being
gaind cures all disgrace in me
y vow was breath and breath a vap

Illuminated manuscript on vellum, size 13 × 9 in (330 × 230 mm)

Why didst thou leave the
trodden paths of men
Too soon, and with weak hands
though mighty heart
Dare the unpastured dragon
in his den?

*Miniature on vellum with gold powder,
raised and flat gold leaf and gouache colours,
size 4 × 3 in (102 × 76 mm)*

Oh, to be in England
Now that April's there,
And whoever wakes in England
Sees, some morning, unaware,
That the lowest boughs and the brushwood sheaf
Round the elm tree bole, are in tiny leaf,
While the chaffinch sings on the orchard bough
In England – now!

*Illustrated verse on vellum, size 4 ×
5 in (102 × 127 mm)*

*Coat of arms with shield in flat aluminium leaf, page size 12 × 9 in
(305 × 230 mm)*

*Illuminated scroll on vellum with raised aluminium leaf capitals,
size 9 × 24 in (230 × 610 mm)*

THE GENUS McALASTERUM

Being three separate species given the family name McAlasterum as they all grow at 172 Stephens Road.

CLIVEII

(Common names, Clivey, Mr. McAllister)

Very popular in London during the 1960's, though seldom seen there now. Can occasionally be seen along railway lines. Cliveii should not be grown in full sunlight as its leaves are extremely tender and blister if subjected to it for any length of time. Cliveii's height might be thought to exclude it from indoor decoration but in fact it can enhance the appearance of most rooms given the opportunity.

Its origin is unknown, though it has links with Scotland and was made popular in the 19th century by the Pre Raphaelite painters, who often depicted it in the background of their work. Its extreme height, equalled only by that of the sunflower sometimes gives it an air of aloofness as it appears above everything. Cross pollination is the best form of propagation as it does not divide satisfactorily. Its dried flowers were used religiously in pagan ceremonies, which perhaps accounts for its still being found in churches to this day. The perfume should be permitted to suffuse the atmosphere as it acts as a tranquilliser on those of an energetic temperament.

Advice to growers - allow to establish, will never become an unmanageable clump, as, for all its height it is most adaptable.

EMILYENSISS

(Ems, The thumb sucker, little person, smiler)

The Ems, as it is commonly called is a plant fast growing in popularity. It grows best at altitude, the third floor being preferred, where it can often be found if the climb to such heights is undertaken. Emilyensiss can often be discovered in fields used by horses as it seems to have an affinity with these animals and the scent of emilyensiss has been remarked upon as being very 'horsey' especially for some unaccountable reason, on Saturdays. In the summer the dancing heads of the plant can be seen under canvas as it is a great favourite at Fetes and Festivals. It is a durable plant at home in town or country. It is best not to have it in the living room for any length of time as it is liable to flop if it remains there too long. It has an insatiable appetite, but should only be fed on inorganic fertilizers as it shows a marked dislike for blood, fish and bone type feeds.

Comments

On the whole Emilyensiss is a sturdy plant when established, though it has been noticed that it is often grown as a wallflower tending to be swamped by more vigorous though less attractive plants. One to grow on its own, free standing, where its beauty can be fully appreciated.

GILLIANA

(The Little Woman, Memsahib, Auntie Gillian)

This is a small rambling plant, one of its many names is 'mile a minute', though this is a slight exageration it does cover the ground at an alarming pace. It is at home as much in a pot in the kitchen as in the garden. It is one of the few plants native to Tunbridge Wells and thrives near churches. It does not seem to grow well in the country, and has never transplanted with ease. It flowers profusely, its blooms more apparent in the evening when the cooler atmosphere enhances its scent. Cats love it and are often found sleeping on it, the crushed foliage emitting a perfume midway between cologne and lavender. It can be used in salads but needs a lot of dressing. Though a small plant it can never be overlooked, as it seems to demand attention all summer long. It is recommended not to plant it too close to other plants as it does not marry well with them, being inclined to choke them. Seedlings should not be placed near the mother plant as the older one suppresses its offspring.

Genus McAlasterum *chart with floral illustration, size 17 × 12 in*
(433 × 305 mm)

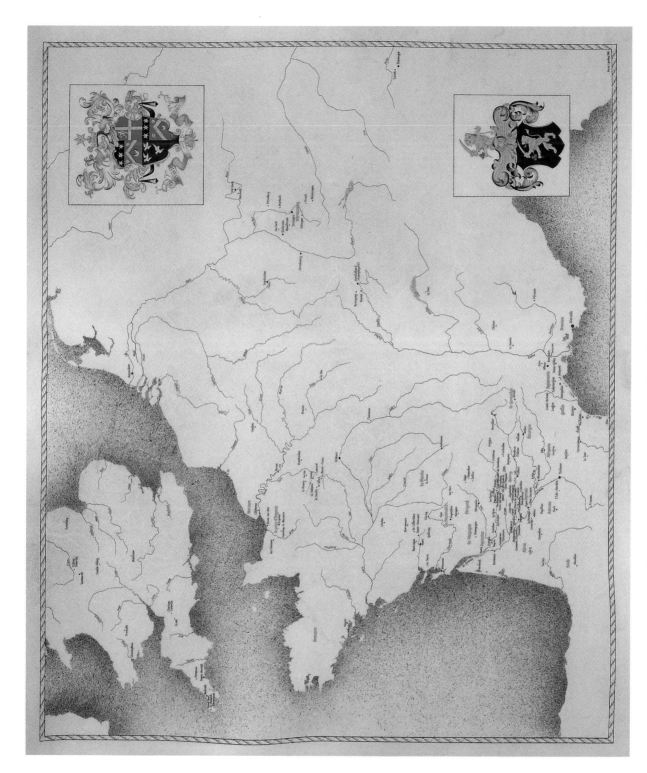

Map on vellum, approximate size 40 × 45 in (1,020 × 1,147 mm)

'Fabriano Ingres', 'Canson Mi Tientes' and 'Arches Ingres' paper

'Marlmarque' and 'Parchmarque' paper

Vellum and parchment skins and imitation papers

Japanese papers

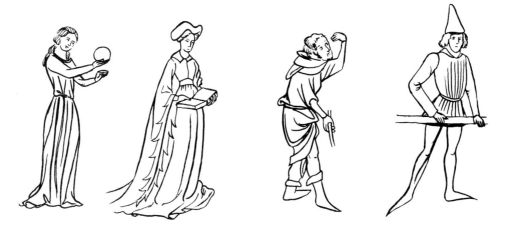

(Fig. 38) Medieval costume

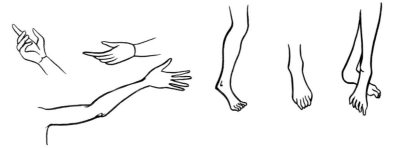

(Fig. 39) Medieval faces

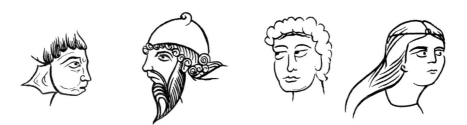

(Fig. 40) Medieval hands and feet

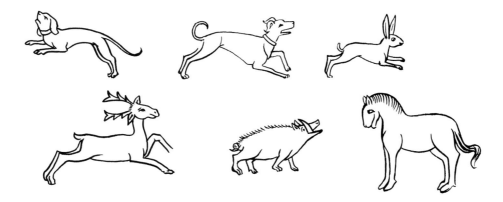

(Fig. 41) Medieval animals

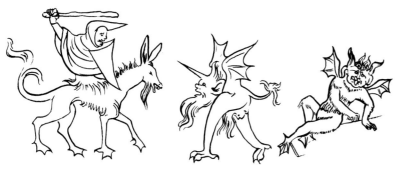

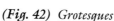

(*Fig. 42*) *Grotesques*

Figures

Faces and other parts of the body are mainly shown with a few boldly drawn lines. Hair is painted with a covering of carefully curled strands (Fig. 39). Hands are often beautifully drawn with long graceful tapering fingers, and the legs and feet are very shapely. (Fig. 40).

On more elaborate pieces skin tones are used with a graduation of pinks, browns and oranges blended into each other and highlighted with white. Simplicity is the best method to begin with. A few lines on a fleshy base colour will suggest enough of the shape to enable the observer's eye to fill in the rest.

Accuracy in the representation of animals fluctuates enormously in those early texts. Dogs are handled quite well, with neatly curved, stylized bodies and springing attitudes. A familiar scene at the bottom of a page is that of a dog chasing a hare or deer (Fig. 41). Other beasts of the chase, farm animals and birds often appear in reasonably recognizable form, but less familiar animals such as lions and tigers are sometimes to be met with in very odd shapes and sizes. The representation of horses ranges from very crude, badly proportioned creatures to very skilfully drawn animals with their riders.

In medieval pictures you will also find many weird and wonderful monsters and demon-like figures, known as grotesques. They feature constantly in religious pictures and you can have fun creating your own gruesome creatures if you wish to (Fig. 42).

Surroundings

(*Fig. 43*) *Medieval perspective*

Apart from the central characters in the picture, the background requires a lot of attention. Perspective was not usually handled

(Fig. 44)

very well at this time (Fig. 43), and you can mimic this mishandling in your own pieces to convey the impression of another age. The chairs and books in Fig. 44 are set at odd angles, but it is this oddness that gives the piece its unmistakably 'medieval' look, coming as it does from an age when perspective was not properly understood.

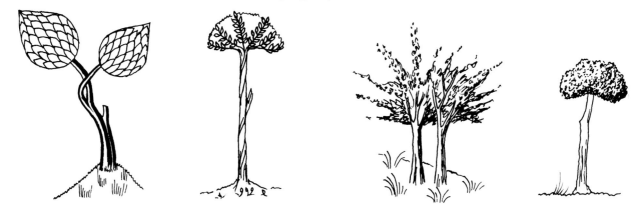

(Fig. 45) *Different styles of trees*

Trees can vary from the very stylized to the more naturalistic (Fig. 45). It is important to keep the whole picture in the same style, so if you have stylized figures make the trees, buildings, etc. similarly stylized, or alternatively give everything a naturalistic approach.

In these medieval manuscripts large background areas are seldom left plain, and what should be blue sky is as often as not red or gold and diapered.

Diaper

The term *diaper* means to ornament the surface or background of something with a small uniform pattern, and to variegate and adorn it with diverse colours.

Small diaper patterns are found extensively on medieval manuscripts and can be extremely useful to illuminators on many other occasions. Apart from being used to cover plain backgrounds they can be employed on particular objects or clothing or simply as space-fillers. You will find countless examples on illuminated miniatures and on all sorts of objects, such as wood and stone carvings in large houses and churches, painted china and pottery, etc.

Diaper can be broken down into three groups: floral patterns, geometric patterns and repeated-motif patterns.

Floral Diaper
This method is very simple and can often be drawn freehand on to the required area. Take a basic stem such as one of those shown above (Fig. 46) and simply work it over the area, winding back and forth and forming new branches where necessary until it covers the entire surface.

In Fig. 47 the shape to be diapered is first covered evenly with the main stem, then the smaller detail is added and any gaps

(Fig. 46) Floral diaper stems

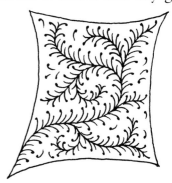

(Fig. 47) Forming an even covering of floral diaper

(Fig. 48) *(a) Unevenly spaced minor stems*
(b) Unattractive stem crossing

filled with a few loose seeds or leaves to give an even texture over the whole area. Little flowers can be added here and there if required. It is important to keep the texture the same throughout — don't let the leaves become more widely spaced or thickly grouped in parts (Fig. 48a). Do not cross one stem over another as the effect will be less pleasing (Fig. 48b).

On an important piece of work it is better to work the pattern out first on tracing paper and then transfer the guidelines to the piece before painting the pattern in. Fig. 49 shows examples taken from illuminated manuscripts.

(Fig. 49) *Floral diaper*

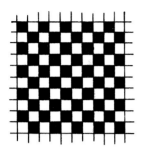

(Fig. 50) Simple geometric diaper

(Fig. 51) Building up a pattern

Geometric Diaper

Although some geometric patterns can be quite complex, most are usually very easily constructed when broken down into stages. Even a simply chequered background can look very effective (Fig. 50). You will normally need to begin a geometric diaper with a grid of squares or diamonds. Successive lines are then added and areas blocked in or shapes repeated, with the effect being gradually built up (Fig. 51). Accuracy is needed for the best effect, and your lines and shapes should be sharp and precise, although sometimes it is better to draw them freehand or along the edge of a ruler rather than with modern drawing instruments such as ruling pens, because too much precision will take away from the medieval feel of the piece.

(Fig. 52) Making a receding surface

You can give perspective to your picture by adjusting the pattern to give the appearance of a receding surface (Fig. 52). You will need to measure the width at the top and bottom and divide both by an equal number. Mark the divisions and draw lines joining up each set of points. Draw in a diagonal from one corner to another, and at each point where the diagonal crosses a vertical line draw in a horizontal one. You now have the basic grid to which you can add further detail. This method was often used to depict tiled floors.

Fig. 53 shows other geometric diapers, all very simple to construct but which give very attractive results.

(Fig. 53) Geometric diaper

(Fig. 54) Dot-pattern diaper

Repeating Patterns

This type of diaper is useful for covering clothing as it is easier to adapt around folds. A series of dots can be used in a number of ways (Fig. 54), or you can employ a simple motif or set of motifs repeated regularly over the surface (Fig. 55).

(Fig. 55) Repeating-pattern diaper

Embossed diapering on gold can be very effective. (The methods of applying gold are shown in detail in Chapter 4). The burnishing tools used to apply the gold can also be employed as embossers. Press down firmly with the point of a pencil burnisher and swivel it round a few times to get bright, shiny dots. Rule your lines with a thin, pointed (but not sharp) stylus and they will shine brightly too (Fig. 56).

The Persians were masters of the art of making incredibly complex diapered pictures. Some manuscripts would be composed almost entirely of different pieces of carefully worked

(Fig. 56) Patterns embossed on gold

pattern, with hardly a plain area to relieve the richness of it all. The patterns in Fig. 57 are all to be found on a single Persian manuscript, and the lower picture Pl. 2 shows a miniature design based on a Persian border and lettering.

Line Fillers
Awkward gaps at the ends of lines of writing can be filled up with diaper or simple pen-made patterns: Fig. 58 shows some medieval examples.

At the time when historiated initials were most popular the scripts used were the Gothic Blackletter hands. There were many slight variations of the letter shapes used in different parts of Europe, but those shown in the following section are the easiest to construct.

Blackletter

The miniscule alphabet is shown in Fig. 59. The letters of this script are very regular and evenly spaced. As always use the *o* to

(Fig. 57) Persian diaper

(Fig. 58) Line fillers

abcdefghij
klmnopqrs
tuvwxyz

(Fig. 59) Blackletter minuscules

regulate the formation of all the letters. The pen angle is the same 30 degrees used for the Foundation Hand, but the writing lines are often drawn to be slightly narrower than the 5 nib widths of that lettering style. This gives the text the heavier, blacker look characteristic of this hand.

Fig. 60 shows the alphabet again, this time within a grid of squares. If you study this carefully you will see the relationship between the widths of all the letters. Accurate spacing in Blackletter is important, and one of the most common mistakes writers of Blackletter fall into is spacing the letters too far apart. This completely destroys the texture that makes this hand so attractive.

The *a* of the Blackletter hand is beautiful, with its graceful hairline connecting stroke. When constructing the letter use the right hand corner of the nib to draw the hairline in with a quick flowing movement so that the curve is nicely rounded.

Little hairlines can be added to some of the other letters purely for decoration. A *t* is ideal for this type of treatment when it is the final letter of a line. This time the hairline is made with the left-hand corner of the nib and the tiny stroke should be a natural continuation of the letter as shown in the first example, rather than a deliberately manufactured appendage such as in the second one.

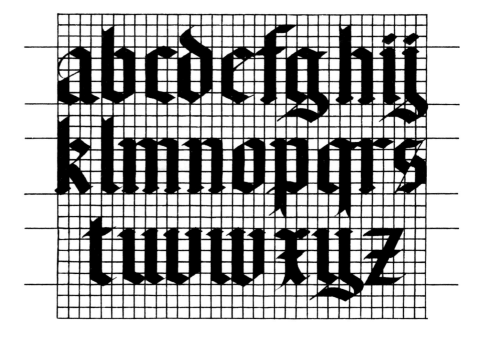

(Fig. 60) Blackletter within a grid

t t

cedfrsk

Other letters which can be treated similarly are shown above, but again, remember not to overdo the effect, as too many hairlines will give the writing an untidy appearance.

ABCDEFG
HIJKLMNO
PQRSTU
VWXYZ

(Fig. 61) Blackletter capitals

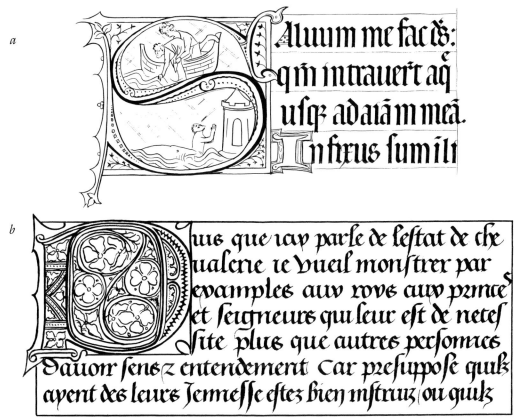

(Fig. 62) *Sketches of historiated initials*

Blackletter is frequently written with a grid of evenly spaced lines, as shown in Pl. 1. This requires a lot of practice to get the letters evenly spaced between the lines but not touching them. You are more or less writing without your usual guidelines although you do have the assistance of the grid. If you already have a tolerably good hand it should not be too difficult to make this jump to writing inside the guidelines, keeping the row of lettering straight and even. The Blackletter capitals are shown in Fig. 61.

Figs. 62a and b show sketches of historiated initials with their accompanying lettering. In Fig. 62a the pen is held at a much shallower angle, enabling the strokes to be terminated squarely with the bottom writing line. Fig. 62b from the late 15th century shows lettering developing a more rounded appearance.

The combination of an elaborate historiated initial and a decorative border can make a beautiful piece of work, especially when this work includes some gold leaf.

4 Gilding

Gold is the most powerful medium with which to illuminate, having a striking effect on any piece of work. Real gold is expensive, but a substitute that can emulate the brilliance of its sheen has yet to be made. Gold is available in either powder or small thin sheets or leaves. In powder form gold is quite easy to apply; using gold leaf is more time-consuming and requires a lot of patience.

Burnishers

When using gold you will need burnishers — pieces of hard, smooth semi-precious stone, usually mounted on to wooden handles for easier use (Fig. 63) — to polish the gold and give it the brightest possible shine. The stone most commonly used is agate or haematite; it is shaped in various ways for different stages of the gilding process. A dog-tooth burnisher is the most

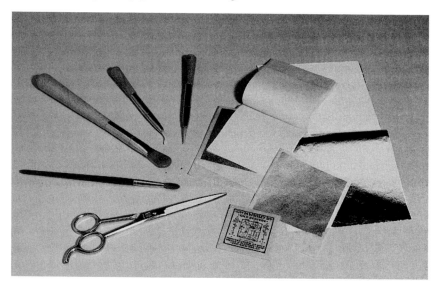

(Fig. 63) Burnishers, gold and aluminium leaf, packet of gold powder, scissors and brush

useful and will be all that is required for use with gold powder. For raised gilding with gold leaf a pencil burnisher is also needed for getting to the edges of the shape. Some pencil burnishers have a very pointed end, others have a slightly blunter, more rounded shape. I find the sharper one to be the most useful. A pencil burnisher can also be used for making embossed diaper patterns on gold and other surfaces. A large flat burnisher can be used to give a heavier final shine to the gold.

Gold Powder

Gold powder is sold in quantities equalling an old penny or halfpenny in weight, written as 1dwt or ½dwt. The powder is wrapped in a piece of thick paper inside a small envelope (Fig. 63) and ½dwt should be sufficient for several pieces of work that need only a moderate amount.

Empty the contents of the packet into a small container that has a lid. I use an empty plastic 35mm film container as it is just the right size and has a snap-on lid. Take care when you open the paper containing the gold as some of the powder invariably works its way outside the main fold — it is too expensive to waste. It is a good idea to unwrap the paper and tip it into the container over another clean sheet of paper so that any spilt gold can be saved and added to the rest.

Distilled water (see p. 69) and gum arabic are used to mix the powder. Distilled water is vital, since any impurities that get into the gold will dull its shine. Gum arabic is needed to adhere the gold to the page, but as this too dulls the shine, you should use as little as possible. Begin by adding about a teaspoon of water to a ½dwt of gold powder, then add five drops of gum arabic. Measure the drops by dipping a small paint brush into the gum arabic and allowing drops to fall from the brush one at a time, into the gold and water mixture. (Small bottles of gum arabic can be bought from most art shops.) Mix with a small brush which you should keep to use only with the gold.

Painting with Gold Powder
Paint a small section (about 1 cm square) with the gold mixture. Don't paint too thickly, but use just enough to cover the paper, then allow to dry for about ten minutes. Using a dog-tooth burnisher, rub gently over the gold in circular movements; it should start to shine brighter. If the gold sticks to the burnisher it is probably still damp, so leave it for a few more minutes. Do not leave for too long, though, as the shine will be brighter if burnished soon after the gold is dry. You should be able to polish very hard after a while without causing the gold to flake

off the paper. If the gold does flake off then more gum arabic is needed but only try one more drop, then test again. Always add gum very sparingly until the required mixture is obtained. Too much gum will dull the brilliance of the gold and in extreme cases stick to the burnisher. If you find that the gold has too much gum you can leave the mixture uncovered for a while and the gum-and-water liquid will gradually evaporate off. You can then add more water. The liquid will evaporate quite quickly but do not let it dry out completely. When you leave the gold unused for a while you will find that the heavy gold particles have separated to the bottom and need to be mixed well again. The mixture will also have dried out a bit and will need more water. A suitable amount of gum arabic will also be needed and you should always test it again to make sure you have the right mixture. Use a small container of distilled water to wash your brush when you have finished. After several washings there will be quite a lot of gold powder collected at the bottom of the container. You can dip the brush into the water and scoop the gold powder up with the brush hairs and return it to the gold pot.

Writing with Gold Powder
Apart from painting with gold powder, it will also flow through the pen, enabling you to write in gold. Make sure to mix the gold thoroughly with the liquid and clean and refill the pen constantly so that the writing edge does not become clogged up with dried gold powder. The powder and liquid will separate very easily and you will find that after every few words the mixture will be becoming watery and will need to be replenished. It does not take long to acquire the knack of knowing when to refill, quickly mixing up the liquid again before applying it to the pen. The letters are then burnished when dry in the same way as the painted areas.

Gold Leaf

Gold leaf comes in two forms, transfer leaf and loose leaf. It also comes in different qualities. Illuminators need the purest type, which is 24 ct. Sign-writers use a less refined quality, measuring 23.5 ct — it is cheaper but will not produce such good results. Transfer leaf is easier to work with, the sheets of gold being stuck to thin backing paper. The sheet is applied to the prepared surface and rubbed on from the back in the same way as children's transfers, except that a lighter, more even touch is needed. The sheets measure $3\frac{1}{2}$ inches square and can be bought in books of 25 leaves, although L. Cornelissen & Son

(see page 142) also sell it in smaller quantities so that you can experiment before committing yourself to a larger amount.

Applying Transfer Leaf

To apply the transfer leaf you will need gold 'size', an adhesive liquid available from gilding suppliers. Paint the size evenly and sparingly on to the work and allow a few minutes to dry. Then slightly remoisten it by breathing over it with a few quick breaths. The reason for allowing the size to dry first rather than just sticking the gold straight on to it while it is still wet is that it never seems to dry evenly and the exact amount of tackiness required is much easier to control by altering the number of breaths. If you try sticking the transfer leaf straight on to the freshly painted area it will either be too sticky or made up of a mixture of very sticky and less sticky areas. You are unlikely to make the size too damp and sticky by breathing on it after it has dried. If the size is too sticky it will come through the gold, making it impossible to burnish and spoiling the surface of your work. Always experiment with any new materials on test pieces before using them on a complete piece of work.

After breathing on the area painted with size, quickly lay a sheet of transfer leaf over it, gold side down. Have the sheet ready in one hand to lay down immediately you stop the breathing. In your other hand have a dog-tooth burnisher ready so that you can start burnishing immediately. Rub lightly and carefully in circular movements over the whole of the sized area. You should be able to see, through the backing paper, where the gold is sticking, and the shape will gradually become visible as you work over it. If the gold seems to be sticking nicely gradually press more firmly. If you can feel or see the size seeping through and sticking to the paper, stop and peel the paper off, then wait until the size has dried out a little more. You can then try again, using fewer breaths on the drier size. If when you peel back the paper the gold has not stuck properly you will need more breaths next time. If it has stuck well you can burnish the gold directly, using extreme caution at first so as not to scratch off the gold. You can use a flat burnisher to apply a heavier pressure after you have used the dog-tooth. This will give as much shine as possible to the gold. Work in small areas over the whole design. You can arrange guard sheets over the parts already done or waiting to be done (Fig. 64) so that they are protected from your hands while you work on other areas. If your sized area has not been completely covered with gold you can touch it up by breathing on it and re-applying a fresh part of the sheet of gold to the uncovered area. The edges of subsequent layers of gold will blend into each other if you are careful with them and use a delicate touch.

The top picture on Pl. 4 shows a miniature on vellum using

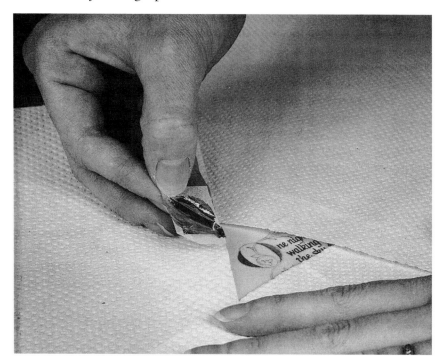

(Fig. 64) Guard sheets protecting area not being worked on

three different gilding methods. The dragon was painted with gold powder, burnished then outlined and modelled with dark brown gouache. The dragon's breath is transfer gold on gold size, and the small shiny spots of gold in the border are loose gold leaf raised on gesso and burnished. The order in which this piece was carried out was as follows: when the design had been worked out on rough paper, the outline was transferred to the vellum. Rough guidelines for the calligraphy were pencilled in and then the lettering was written with Chinese stick ink. Gold size was then painted on to the relevant area and the transfer leaf applied as explained above. Next gesso was painted on to the small spots in the corners and the loose leaf applied and burnished. (The full methods for making gesso and applying loose leaf are explained below.) The gold powder was then painted on to the dragon. There are two reasons why it is important to do any gold work on a piece before any colours are added. The first is that gold leaf will stick to paint (which contains adhesives), the second is that if you burnish painted areas they will shine, too. This might seem like no great problem, but it is not easy to get a uniform shine over an area of paint, and you are more likely to produce an uneven series of streaks on the paint and sometimes make black lines across the surface. You can paint over gold powder quite successfully, but with loose or transfer leaf this is not advisable as these resist the paint. The colours on this piece were gouache as usual, the base colours for the rocks were thin washes over which darker shades

were added and the border used the usual thicker consistency of paint, modelled up and highlighted as described on page 41.

Loose Leaf

This type of gold is purchased in the same way as transfer leaf, in 3½-inch square sheets and books of 25 leaves (Fig. 63). It comes in two thicknesses, single and double (or extra thick). You can use the single thickness in the same way as transfer leaf, applying it to size and burnishing first through the backing paper and then directly. It is better to cut a piece to fit the sized area before applying it, as sheets of gold leaf very easily crumple up and become useless. Cutting gold leaf is often no easy task, since gold sticks to anything remotely adhesive, including greasy fingers. You will need a pair of very clean, sharp scissors. The leaf is so light that the slightest breath of air will send it wafting away, so make sure you are working in a draught-free place. Open the first page of the book of leaves as shown in Fig. 65, holding back the cover with your fingers and thumb so that it will not get in the way when you cut. Cut out a small piece, cutting through the backing paper as well. You can then pick it up very carefully at a corner before applying to the work. You will very soon discover that this seemingly simple task is fraught with difficulty. The gold can stick to the scissors and tear as you try to pull them away. You will need a delicate touch and lots of patience to acquire the knack of cutting quickly and efficiently. If you experience great problems, perhaps from unclean scissors, then try placing a piece of waste backing paper over the

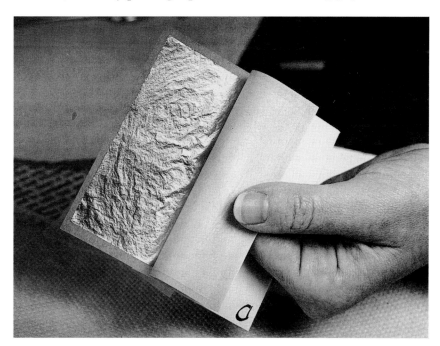

(Fig. 65) Handling gold leaf

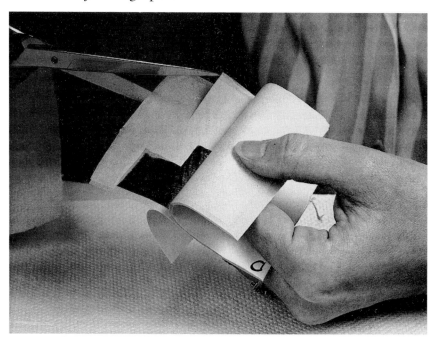

(Fig. 66) Cutting a piece of gold leaf

gold to be cut so that the sheet of leaf is sandwiched between two backing sheets (Fig. 66). Cut though both sheets then remove the front sheet before applying the gold. This will usually prevent the scissors from sticking to the gold.

Another method of cutting up a sheet of gold leaf is by using a gilder's cushion and knife. These can be purchased from the suppliers listed on page 142. You will also find that a paper guard to place around the cushion and keep draughts away is essential. Lay a whole sheet of gold on to the cushion. Taking the knife, cut into squares using quick, light-pressured cuts. Each piece can then be picked up with a brush or gilder's tip and applied to the work. As you do not have the backing paper to first burnish through, a soft piece of clean cloth is needed to press the gold leaf lightly on to the sized area before burnishing directly. For beginners the first cutting method is probably the simpler and does not require the purchase of additional equipment.

Raised Gilding
The next stage is raised gilding, the most impressive type of illumination. It is a long and tiring process, but your efforts will be well rewarded. The leaf is applied to a plaster base called gesso, which has to be very carefully prepared. The plaster needs to be firm enough to take the gold and to allow a bright shine with the use of burnishers, but also pliable enough to bend slightly with the page when the work is handled. Most of the ingredients for gesso (as well as ready-made gesso) can be

purchased from gilding suppliers. If you prefer to make your own, the methods are given below. The principal ingredient is slaked plaster, and this alone requires a good deal of preparation.

Slaked Plaster

Plaster of Paris is used for gesso, but it needs to be treated before it can be used. You can buy the plaster in boxes from chemists; you will need 1lb. You will also need a clean plastic bucket and several gallons of distilled water. Do not use tap water as it contains all sorts of unwelcome purifiers. Distilled water can be bought in gallon containers from chemists and also in litre bottles from garages. You can buy it gradually as you need it, since the process takes several weeks to complete. Start with a gallon and a half of water in the bucket. Sift the plaster in slowly, stirring all the while with a wooden spoon. You will find that a long-handled one is preferable. You might find it easier to get someone to help you so that they can stir while you sift. You need to continue stirring for at least another hour so that the plaster is well and truly soaked and in no danger of setting.

Leave the bucket, with a cloth over it to prevent dust settling into it, for 24 hours. When you return to it, the plaster should have settled on the bottom. Carefully pour off the water, trying not to disturb the plaster so that you lose as little as possible. Top up the water again and stir it for 15 minutes. This process needs to be repeated every day for a week, then every other day for a further four weeks. At the end of this time, pour off all the water, tip the plaster into a piece of linen or muslin, and carefully squeeze out as much of the water as you can. Turn the ball of plaster out onto a plate and store it in a clean, dry place for a few days to dry out. When it has become fairly firm, cut it into four or five pieces and allow them to dry out completely. The plaster is now ready for use, and can be stored until needed. This quantity of plaster will make many batches of gesso, and you will probably not need to make another batch for several years.

Having made the plaster you can now proceed with the gesso. The recipe given below is a tried and tested one that will give good results (see Fig. 67).

Gesso

Ingredients:
8 measures of slaked plaster
3 measures preserving sugar
1 measure white lead
1 measure Seccotine glue
Pinch of Armenian bole
Distilled water

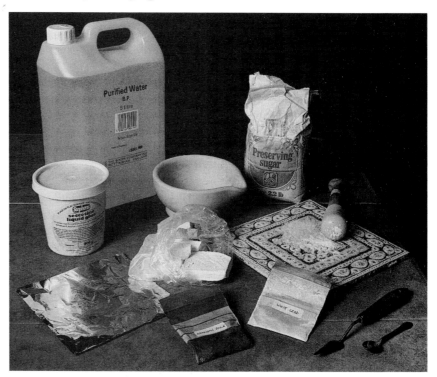

(Fig. 67) *Gesso ingredients and
equipment*

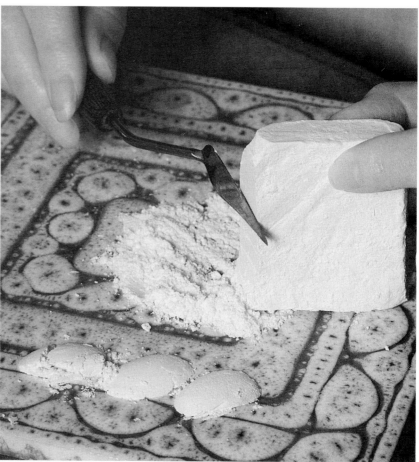

(Fig. 68) *Grating and measuring
slaked plaster*

Equipment: Glass slab and muller
 Palette knife
 Small measuring spoon
 Pestle and mortar
 Tin foil

Take a lump of slaked plaster and grate off enough on to the glass slab with a sharp, clean knife so that you can clearly measure 8 level spoonsful (Fig. 68). A teaspoon is rather a large measure, so try to find one smaller, such as ½-teaspoon kitchen measure or a mustard spoon. Carefully measure each spoonful so that you have an accurate amount and place them in the pestle. The preserving sugar (available from supermarkets) comes in crystals, and needs to be ground to powder with the muller or your mortar against the glass slab then measure out the 3 level spoonsful. White lead is available from gilding suppliers. It is a very fine powder and should be treated with care as it is toxic. Add the level spoonful of this to the other two ingredients in the pestle. Seccotine glue can be purchased from some hardware stores or the suppliers listed on page 142. Take care to add exactly the level spoonful. A small pinch of Armenian bole is needed to colour the mixture so that it will show up on the vellum or paper you are working on, making it more easy to work with. Finally, add the distilled water. The quantity will vary slightly depending on the size of your measuring spoon, but start with 4 or 5 spoonsful. Make sure the mortar is clean before you begin grinding and mixing the ingredients. You will need to grind continually for a good hour. The consistency required is that of treacle, so if the mixture becomes thicker add a little more water. Now and then you can scrape the mixture down from the sides of the pestle and mortar with a palette knife, so that every bit becomes well mixed and smoothly ground.

When the grinding time is up pour the mixture in a circle on to a piece of tin foil about 6 inches square. It is important to correctly distribute the ingredients. As the gesso dries, some ingredients tend to work themselves out to the edge of the circle and some to the centre, but by cutting the dried gesso into 12 equal segments across the centre (Fig. 69) you can be sure of having an equal amount of each. Leave the newly mixed gesso to dry for several hours until it is reasonably solid before cutting with a sharp craft knife. Leave for a further day to dry out then carefully peal off the foil, touching the gesso as little as possible. Store the pieces in an airtight tin ready for use.

Ready-made gesso is available from the Duchy Gilding Company (page 142) but there is a lot more pleasure to be gained from being able to carry out the entire gilding process with your own skills, without having to rely on ready-made items.

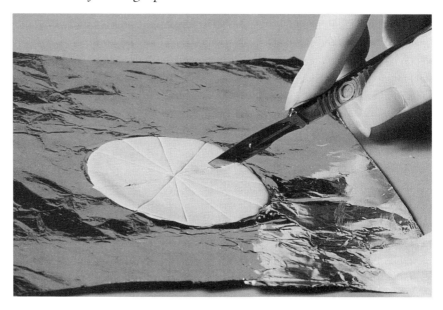

(Fig. 69) Cutting gesso into segments

(Fig. 70) Mixing up a segment of gesso

Working with Gesso

You will need a small dish or palette in which to mix the gesso, a small paint brush, a craft knife and distilled water. Take a segment of gesso, whether your own or shop-bought, and break it up with the knife into small pieces in the dish. Try not to touch the gesso too much — if necessary use a piece of foil to

hold down the gesso while you cut. Gesso can be very hard and difficult to cut if it has been left for some time before use. Pour a couple of teaspoons of distilled water over the pieces so that they are all covered and can soak up the water. Do not overdo the amount of water, use just enough to enable all the pieces to become damp. Allow the gesso to soak for about 20 minutes, then take the small paint brush and, using the end, stir very carefully to mix the gesso and water (Fig. 70). If there are still hard lumps of gesso leave for a while longer before stirring. Stir very slowly and delicately to prevent any air bubbles forming in the gesso, since they will stay there when the gesso is painted on to your work and you will not have a nice smooth surface to gild but one pitted with tiny holes. The consistency of the mixed gesso needs to be something like single cream, so if you have made the mixture too runny, start again with a new piece using less water. If it is too thick you can, of course, add water, so initial caution is the best approach.

If you find having mixed the gesso that you have created a lot of air bubbles there is a way of removing them to some extent. Boil a kettle of water and pour out a cupful. Hold the dish of gesso above the cup (I use a glass jar which the dish can rest on without needing to be held) and the heat will start the bubbles popping. There is a danger of the gesso starting to dry out with the heat, so don't leave it there too long.

The gesso is now ready to paint on to the work. I usually colour all the areas on the rough where gold is required yellow so that I know exactly where I shall be painting the gesso on the actual piece. You must work on a flat surface rather than a tilted drawing board so that the gesso dries evenly. Use a small paint brush and have a pot of distilled water ready for rinsing the brush out now and then. In Fig. 71 a single initial letter is being gilded. The hand that applies the gold is resting on a piece of tissue so that it will not come into contact with the work. Paint each piece with an even layer of gesso, about 1mm thick.

You can also write with gesso, though it needs to be a little thinner than you would paint with to enable it to flow smoothly out of the pen. You will find a quill pen is better than a metal nib for applying gesso. Although you will need to write on a sloping board, try not to allow too much gesso to flow to the bottom of each letter or you will end up with letters thick at the bottom and thin at the top.

When you have covered all the relevant areas with gesso leave the piece to dry for four to five hours, or preferably overnight. This is necessary so that the gesso will be dry right through. If the core is not dry but the outside is then it will almost certainly crack when you apply pressure with the burnishers.

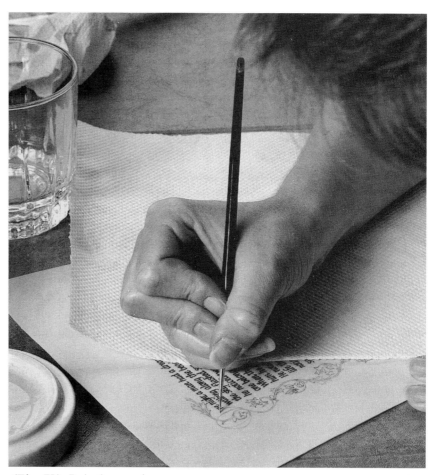

(Fig. 71) Painting on the gesso

Applying Gold Leaf

Morning is often the best time for gilding, while the atmosphere is still cool and damp. Have your gilding tools — scalpel or craft knife, scissors, gold, brush, burnishers, etc. — at hand. It is also useful to have a box or jar for putting the waste gold in. You will need to work on a flat, hard surface such as a marble or glass slab, so that the gesso cannot bend while you are working on it.

As you work on each area of gesso it is wise to have guard sheets covering the rest of the work, as previously explained, so that you do not accidentally touch any of the gesso or allow any bits of loose gold or gesso to come into contact with it, and also to prevent your breath moistening other areas before you are ready to work on them. Have three sheets of paper which you can arrange around the part you are working on. Alternatively you can cut a square out of a sheet of paper and position this over the area to be worked on.

If the piece of gesso you are going to start with is nice and smooth you can start on it right away but if, as is usually the

(Fig. 72) *Scraping the gesso smooth with a scalpel*

case, the surface is not absolutely smooth then use the craft knife to very gently scrape the surface smooth (Fig. 72). You cannot afford to be heavy-handed with this or you will make the gesso far worse than it started, so proceed with caution. The slightly roughened surface is often an advantage, as the gold seems then able to get a better hold on the surface when it is applied. Slight bumps can often be burnished out as the gesso is softened slightly during gilding, but try not to rely on being able to do this.

Cut a piece of the single-thickness gold and hold it between the fingers of one hand (Fig. 73). Bending over the gesso with your mouth about 2 inches from the work breathe on to the gesso to moisten it. Start off with about 10 breaths; as soon as you have counted the tenth lay the gold over the gesso, lightly pressing it on through the paper with your fingers. Take the dog-tooth burnisher and cover the surface with light circular movements to make the gold stick to the gesso (Fig. 74). You will probably be able to see through the backing paper and tell whether the gold is sticking. Peel the paper away when the gold

*(**Fig. 73**) Holding a piece of gold and backing paper between the
 fingertips*

has stuck and gently burnish directly on to the gold. If all has
gone well you will start to produce a bright shine as you
burnish. Remove the excess gold from around the shape with
the soft brush (Fig. 75). Take the pencil burnisher and carefully
burnish the edges (Fig. 76). Go on to the next area of gesso,
remembering to cover up the piece just done. When you have
covered all the gesso with a layer of gold repeat the process with
a second layer, but this time use slightly fewer breaths. The gold
should stick more readily this time as it will have the first layer
to adhere to. Finally, use a layer of double-thickness gold, and
after burnishing with the dog-tooth and pencil burnishers,
finish with a slightly firmer burnish using the large, flat
burnisher. Fig. 77.

In Pl. 2 the top piece of work has a lot of raised gilding in very
small areas. This gives a very rich covering of gold without the
problems encountered in gilding large areas of gesso. Large
areas can look very stunning but there is more likelihood of
winding up with patches where the gold will not stick, uneven
surfaces, crazing (see below), etc. All the gold work on this
piece was carried out after the writing was complete but before
the painting. Long thin lines of gesso, as used in the border of

(Fig. 74) Burnishing lightly through the backing paper with a dog-tooth burnisher

Pl. 3, are very easy to gild. Lengths of about 3 cm were laid each time, and as each piece blended into the last the lines were smooth continuously along each length.

Problem Areas

It is very unlikely that all will go smoothly on your first attempt. The most likely problem will be that the gold doesn't stick and this could happen for a number of reasons.

1. The gesso has not been sufficiently moistened with the number of breaths used. You can increase the breaths up to about 25 after which you will probably be too exhausted to go through the rest of the process. Often about 15 to 18 are needed to give sufficient moisture to the gesso. It occasionally happens, especially if you begin gilding in the afternoon, that the atmosphere is just too dry and hot to enable the gesso to be moistened sufficiently. If this is so it is better to postpone gilding until conditions are better. This does not often happen with freshly prepared gesso however. You are more likely to have this problem if you have left the gesso for several days before gilding and it has become too hard and dry.

2. The gesso has been spoiled in some way. This is usually

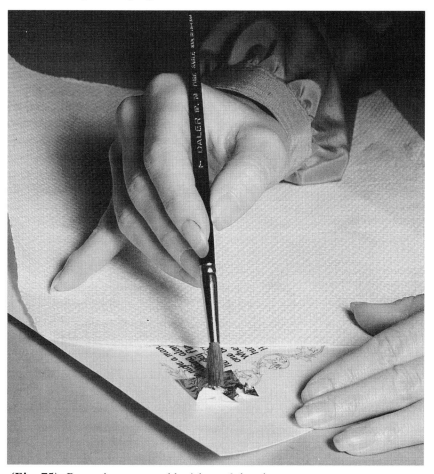

(Fig. 75) Removing excess gold with a soft brush

caused by greasy fingers having touched the gesso. When this has happened there is often no way of getting the gold to stick to the gesso, and the only solution is to carefully scrape off the spoiled gesso with a craft knife and start again.

3. Your gesso might have insufficient adhesive in it. This could have happened because too much water was added when preparing the gesso segment for use. If this was the case you will need to remove all the laid gesso, prepare another segment and start again. If the problem lies in the actual gesso you will have to make a new batch, being careful to measure exactly the right quantities of each ingredient, or erring slightly on the generous side with the sticking ingredients, i.e. the glue and sugar. The disadvantage of additional amounts of these ingredients is that they will reduce the brightness burnishing can achieve.

If your problem is that the gold has stuck too well, so that the gesso has become sticky, adhering to the paper and possibly the burnisher once the paper was removed, then you will simply need to decrease the amount of breaths you give the gesso.

If the gold has stuck to some parts of the gesso but not

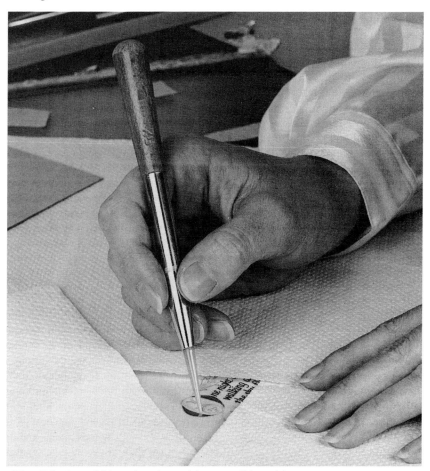

(Fig. 76) Burnishing the edges with a pencil burnisher

(Fig. 77) The completed gold letter

covered the whole area, then you can apply another layer, giving particular attention to the uncovered parts when burnishing. This will usually solve the problem, but if there is a spot that will not be covered it has become soiled, and the gesso will need to be removed and re-applied.

'Crazing' is a more irritating problem as it usually occurs after the second or third layer has been added. This is when the gesso cracks up, giving the whole surface a covering of fine hairline cracks. There is nothing to be done but remove the gesso and start again. It usually happens when too much pressure is used while burnishing.

If you do need to re-apply gesso to part of the work, use a freshly mixed segment, do not just add water to what was used the previous day. If you do not manage to finish all the gold work in one day, or if you have to wait until conditions are more favourable, try to get the gilding done as soon as possible. If you have to leave the gesso ungilded for more than four days it will become very dry and will be much harder to gild.

You must be prepared when gilding to have a lot of patience and be prepared for disappointment as well as success. It is very discouraging to have to remove gesso which will not be covered or which has crazed, especially when a lot of time has already been spent in reaching this stage, but it is not time wasted as you will have learnt from the experience and will know better next time. It is worth persevering, as gold does not tarnish with age and if you have carried out the work well it will be beautiful for ever more and give you and others a lot of pleasure.

Aluminium Leaf

Aluminium leaf is much cheaper than gold, and the sheets are larger (Fig. 63). The procedure for applying it is identical to gold leaf except that only one layer can be applied as aluminium leaf does not stick to itself. You will also need a gesso with slightly more glue and sugar to provide extra sticking power. Add another half measure of each of these ingredients.

When the piece of leaf is laid on to the gesso burnish it quickly and very carefully so as not to scrape the aluminium off before it has had a chance to stick. The double-stroke letters and parts of the coats of arms in the bottom picture in Pl. 5 are raised aluminium leaf.

Aluminium laid flat on gold size is much easier to do, and if well burnished the shine can be very bright (top picture Pl. 5).

Silver leaf is also available for illuminating, but although initially producing very good results, it will tarnish and become black within a few years.

5 Vellum

Vellum is the specially prepared skin of calves, sheep or goats, and was the writing surface used before the introduction of paper in Europe. Medieval manuscripts, maps, charts and all sorts of documents written and painted on vellum have survived well, since the material is very durable if kept in reasonable conditions.

Vellum is a very nice surface on which to write, having a soft, velvety, slightly springy surface if well prepared. There are very few manufacturers in existence now and vellum is therefore costly, but it can be purchased in small pieces as well as whole skins and it is well worth trying. You will find several different types of vellum available (Pl. 8).

Types of Vellum

Manuscript vellum — This is the smoothest, whitest vellum, and it is prepared on both sides for writing. The skins are quite thin and if flawless can be mistaken for paper. It generally needs very little extra preparation before being worked on.

Classic vellum — This type of vellum has less of the natural colour bleached out during manufacture and is very attractive, with a network of veins running over the surface.

Natural vellum — The colouring in these skins is quite dark and the surface much coarser, but again it is very attractive. The skins require a lot of additional preparation before they can be written on satisfactorily, but it is well worth the trouble for the beautiful effect obtained.

Goatskin vellum — Goatskin is inferior to calfskin. The surface has more marked pores from the animals' hair, giving a speckled appearance to the skins, which are obviously much smaller than the calf vellum. The colours vary from off-whitish grey to cream.

Parchment — This is the skin of sheep and it is much thinner, whiter and more delicate than vellum. The surface is very delicate and can easily be spoilt by harsh treatment. Parchment is sometimes stained with colours.

(Fig. 78) Thick and thin sections of a vellum skin

Vellum is sold in square feet, an average calfskin being about 8 square feet. The line of the backbone of the animal is thicker than the rest of the skin and is quite visible on the darker skins and can be seen when held up to the light on the paler ones. The corners also have thicker portions, while the middle of the sides are the weakest, thinnest areas (Fig. 78). When choosing a portion of the skin for working on it is useful to bear these things in mind. For a large piece of work, try to have the backbone running down the centre. You will frequently find skins with quite marked blemishes and even holes, yet these are not offered more cheaply because they take just as long to make. If you are ordering by post make sure to specify if you need a large unmarked area. It is possible to buy skins as large as 14 square feet but they tend to be very thick and coarse, making them more difficult to prepare and write on.

When the animal skins are treated they are stretched across frames. This flattens them out, and provided they are kept cool they will remain fairly flat when removed. As soon as they become warm however, they will start to curl up and try to assume their original shape. This can be a nuisance when working on a piece, but can be avoided by stretching the vellum over board either permanently or just while you are working on it.

Stretching Vellum

To stretch vellum it is wrapped around board of a suitable thickness and the overlapping edges glued to the back of the

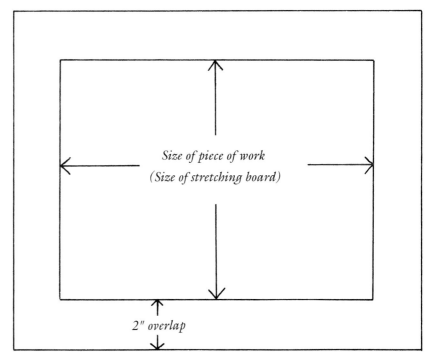

(Fig. 79) Cutting vellum with an overlap for stretching

board. When the work is complete it can either be framed as it is or cut away from the board. Plywood from ¼-inch to ½-inch thick is used for the stretching boards depending on the size of the piece of vellum. Small pieces of vellum under 12 x 12 inches in size can use the ¼-inch thickness, larger pieces ³/₈-inch thick, and pieces approaching a whole skin in size (6 to 8 square feet) will need ½-inch thick board. If in doubt use a thicker piece, as vellum is strong and can easily warp thin board when stretched over it.

The board must be cut to the same size as the piece of work,

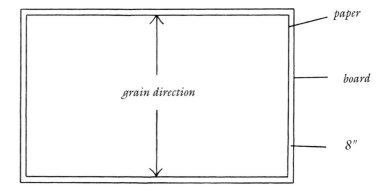

(Fig. 80) Cutting paper for vellum stretching

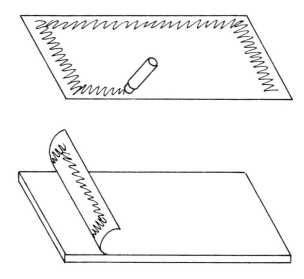

(Fig. 81) Sticking blotting paper to the stretching board

or to a size slightly larger if you intend to cut the vellum off the board when the work is finished. Sand the edges smooth if they are coarse from cutting. The piece of vellum must be the required size plus a turnover of 2 inches on each side (Fig. 79).

You will also need a piece of good-quality paper (hand-made

(Fig. 82) Marking and mitring the corners

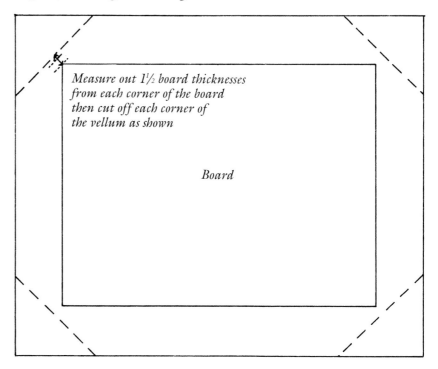

*Measure out 1½ board thicknesses
from each corner of the board
then cut off each corner of
the vellum as shown*

Board

(Fig. 83) *Damping the vellum*

if possible) for backing. This must be cut ⅛-inch smaller than the board on each side, with the grain direction of the paper parallel with the shorter sides (Fig. 80). The grain of the paper is the way in which the fibres lie, paper is stronger against the grain, helping to counteract the pull of the vellum. Hand-made paper is preferable as it generally has a less pronounced or even no grain direction, thereby counteracting the vellum's pull in both directions. A piece of white blotting paper is also needed and should be cut to the size of the board and stuck down with a glue stick, as shown in Fig. 81.

The other items required are heavy-duty wallpaper paste with fungicide, a clean sponge, a bowl of water, a bone folder, a toothbrush for mixing and applying the paste and some sheets of brown kraft paper to place under the vellum while you are working.

The wallpaper paste should be mixed before you start the rest of the stretching process. Put about a tablespoon of the powder into a cup and add enough water to get a thick but spreadable paste. The toothbrush can be used for mixing.

Your work surface should be clean and covered with several sheets of thick brown paper to place under the vellum while you are working. The sheets can be removed one at a time as they become messy from glue or water. It is important to keep the working side of the vellum free from water or glue at all times as these will leave marks.

Mitre the corners of the vellum after marking them off as shown in Fig. 82. Make sure that the working side of the vellum is always facing downwards so that it is stretched on to the board the right way up. Damp the vellum with the sponge to make it expand (Fig. 83). Remember when dampening the

(Fig. 84) *(a) Sticking down the edges*

(b) Folding in the corners

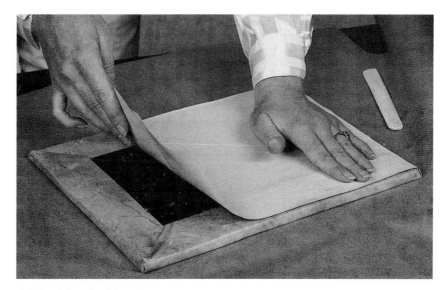

(c) Applying backing sheet

vellum that water must not be allowed to get on the working side. Rub the dampened sponge carefully over the vellum, moistening it just enough to see that it becomes soft and expands but not enough to allow the water to sink right through to the other side. Thicker parts need more dampening, while thin parts will require only a quick brush over with the sponge. The vellum will curl up as it expands, but take care that it doesn't roll up completely.

When you are satisfied that the vellum has expanded as much as possible it is ready to be glued to the board. Place the board on the vellum carefully, with the corners touching the pencil marks. Spread a layer of glue along one of the long sides of the vellum, along the edge of the board and 2 inches into the board (Fig. 84a). Wrap the vellum over the edge and using the bone folder, smooth it on to the board as closely and firmly as possible. Do the same with the other side, pulling the vellum tightly across so that there are no wrinkles on the front. (Don't lift the board up more than absolutely necessary so that there is less danger of the working side of the vellum becoming marked with water or glue.) Follow the same procedure with the short sides, then fold in the corners neatly (Fig. 84b).

Lift the board up and remove the top sheet of brown paper from your work surface, laying the board down on a clean sheet. Damp the piece of hand-made paper, and while it is expanding, cover the whole of the back of the board with a thin layer of glue. Lay the paper on and smooth it down very carefully with the bone folder. It is very easy to tear the soft wet paper, so use light strokes.

Stand the board up on one edge to dry, rotating it now and then so that all the edges have a chance to dry. Try to leave the

board over night before you work on it to be sure it has dried out completely. The vellum will have shrunk again so that it will be tightly stretched over the board.

If you wish to remove the vellum from the board when the work is finished, just place a metal rule on each edge and cut with a knife. As the front of the vellum was not stuck down it will come away easily, and provided it is kept in a reasonably cool atmosphere, should stay flat.

Pouncing Vellum

Before writing on a piece of vellum it should be rubbed with a powder called 'pounce'. This removes grease and dirt from the surface and raises a slight nap that helps hold the ink and smoothes away any unevenness.

When you have chosen and cut your piece of vellum to the correct size (and stretched it if necessary) it is ready to be pounced. Pounce is available from vellum manufacturers and some of the suppliers listed (see page 142) or you can make you own. The ingredients are powdered pumice, gum sandarac and powdered cuttlefish. The pumice and cuttlefish remove grease and abrade the surface while the gum sandarac helps the vellum hold ink. The powdered pumice is very fine when purchased but the cuttlefish, which can be purchased from pet shops, needs to be ground down very finely, as does the gum sandarac which is

(Fig. 85) Pouncing vellum

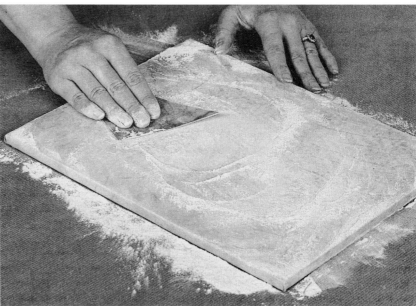

brought in crystals. The powders are mixed together and must be very fine. Any large lumps will leave scratch marks on the vellum, so it is a good idea to put them through a fine sieve. The mixture I have most frequently used is a heaped tablespoon of pumice, another of cuttlefish and a teaspoon of gum sandarac.

Vellum has a smooth side (the hair side) and a coarse side (the flesh side). Both can be written on, but if you have a choice use the smoother hair side.

You will need to rub the powder over the surface of the vellum. A piece of scrap vellum can be used for this. Sprinkle the powder liberally over the hair side of the vellum and rub methodically with circular movements round and round covering the whole surface (Fig. 85). Continue for five minutes then check that the surface is nice and smooth. Continue longer if the piece is large or particularly coarse, but if it is a thinner more delicate one take care that you do not overdo the abrasion and roughen the surface too much. Only a slight nap is required.

The flesh side needs a more watchful approach as it is easy to raise up fibres that will be difficult to write over. It is a good idea to have a trial piece to test out first before going on to do the main piece.

Parchment needs very little pouncing — it is too easy to spoil the smooth surface and make it coarse, so give only a very light quick pounce to remove any grease and dirt.

If you need a very large skin for a piece of work and the skin is very thick and coarse it can be initially rubbed with fine sandpaper before pouncing, but again proceed with care, checking the surface constantly. You are unlikely to over-pounce vellum unless you get really carried away, but it is too expensive to risk spoiling.

When the pouncing is finished pick up the vellum by a corner and shake off the excess powder. You can also lightly brush off further powder with a piece of tissue but do not rub it away or you will crush the nap again. From now on touch the surface as little as possible so that no dirt or grease gets on to it again. Always work with guard sheets under your hands and transfer pictures with tracing paper, etc., rather than drawing straight on to the work if there is any danger of changes needing to be made or rubbing out to be done. Unless you use a very light touch any pencil lines you make on vellum will leave an impression which often can't be got rid of if you subsequently want to change them.

Removing Errors or Blemishes

Vellum has a big advantage over paper in that errors can be very

successfully removed. Either a hard rubber such as a typewriter rubber or a craft knife or scalpel can be used to rub or scratch off the mistake. Black ink can usually be removed without a trace but some colours, red in particular, can be more stubborn. Give the area a slight burnish afterwards to smooth it down a little.

Occasionally you might come across patches in a vellum skin which are rather porous, causing the ink to spread. A little gum sandarac powder spread on the area should help to prevent this. Another problem might be a grease patch; this can be treated with a little pumice rubbed carefully on to the relevant area. Dust off any loose powder so that it will not clog the nib when you continue writing.

When it is framed and hung on the wall in a warm room vellum is quite likely to buckle slightly, but this can often add to the attractiveness of the piece. If vellum is kept in conditions that are too damp mould has been known to grow on it, so try to keep it away from excessively damp places. If well looked after vellum will still be in excellent condition in years to come, long after paper would have become brittle and discoloured with age.

6 Designing Illuminated Charts

Illumination should not be confined to the decoration of medieval-style manuscripts. It can be used on all sorts of pieces of work in varying styles and sizes. This chapter deals with its use on charts, certificates, or any other document where attractive embellishment is desired.

Whatever the nature of the piece, be it a certificate or contract, an award for a special achievement, a commemorative anniversary or birthday scroll or simply a chart concerning your favourite hobby or something that particularly interests you, the procedures are the same.

Layout

As always, careful planning is necessary when designing a decorative page where a combination of different lettering styles and sizes as well as some sort of illustration or illumination will be used. The lettering styles need to complement one another, the colours to combine well together and the general arrangement of text and illustration to form a pleasing and well-balanced overall effect. It is easy enough to take some information and write it out with a bit of embellishment here and there, but if you give more thought to a piece in the initial stages the end result will be more interesting and attractive.

Arranging the Contents

When you begin on a project of this sort, assemble a list of the contents, e.g. title, sub-titles, general text, illustrations, etc., and decide on the level of importance you want to give each element. For example, the title will usually need to be in a larger, bolder style than the rest of the text, but it needn't always be the predominant part of the lettering. As shown in Pl. 5, the title of the scroll, though larger than the main body of the text, is dominated by the larger lettering further down. Sub-titles or other important pieces of text can be emphasized with colour, size or style of lettering to differentiate them from the rest of the text. The main bulk of the text will be in a smaller and

probably simpler lettering style, but there might be one or two words that could be picked out for emphasis. The more opportunity you create for variety the more chance you have of designing something attractive and interesting. You can always discard ideas that are too fussy or unattractive after you've tried them in rough, but by constantly experimenting with new styles your pieces will always have freshness and vitality.

Trial Sketches

Make a few sketches of possible layouts on rough paper, not necessarily to size but just to give an initial impression of the overall effect. Try several different arrangements even if you

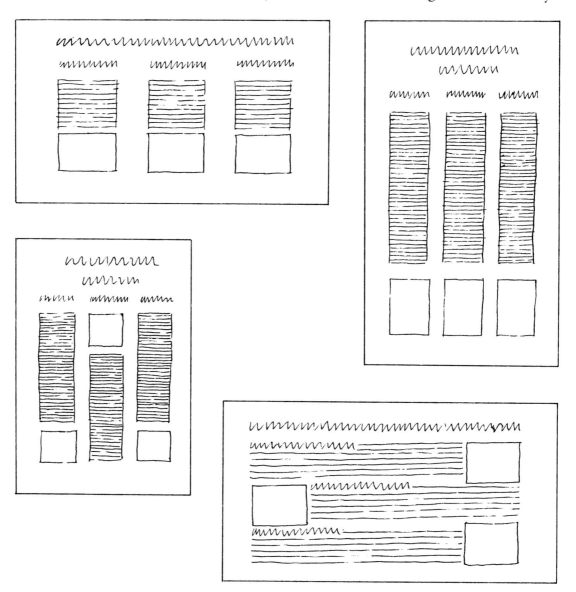

(Fig. 86) Trial sketches

Very popular in London during

Very popular in London during the 1960's

Very popular in London during the 1960's

(Fig. 87) *Trying out nib sizes*

have a fairly firm idea of what you want. You might find when ideas are transferred on to paper that what you first thought would work would be difficult to achieve or could be improved upon. Don't overdo a first attempt, but on the other hand, a challenging new approach is one of the best ways of learning even if it is not always successful. Most complex pieces can be broken down into smaller stages that are not nearly so daunting. Fig. 86 shows the initial layout ideas for a piece of work on a 'species of plants'.

Combining Lettering Styles and Sizes
Once you have settled on a general layout you will need to establish the sizes of each of the pieces of lettering and how much space each will occupy. Sketch the layout you have chosen on to a large sheet of layout paper in roughly the size you wish to end up with, then, using the nib-size chart (see page 16) for guidance, estimate the nib size you will need to use. Work on the main text first, writing out the first few lines to see if the size you have chosen is suitable (Fig. 87). Try a couple of other sizes even if your first seems acceptable as you might find that another would be better. Work through the various parts of the text, comparing each size and style with those already decided upon, and if necessary altering previous decisions to suit the rest. Assemble the different bits of lettering on the sketched layout using masking tape so that you can peel them off and rearrange them as required. Make the title the last part to be decided as this will be the most prominent part of the work and therefore needs the most careful attention.

For the smaller lettering sizes don't be tempted to use over-fussy lettering styles such as Blackletter as they become very difficult to read. You can use different textures as well as different sizes and styles by altering the line spacing for various parts of the piece (Fig. 88).

(Fig. 88) Using blocks of different textured lettering

(Fig. 89) Decorative letters for titles

(Fig. 90) Ribbon scrolls

Titles

For titles and other prominent words you can use drawn letters from some of the many innovative alphabets that you can find in all sorts of places, or you can try inventing your own. Fig. 89 shows a few possibilities, including the double-stroke capitals found in Pl. 5.

Ribbon-like scrolls make attractive headings, and you can introduce as many twists and turns as required to fit the number of words you have or the space available (Fig. 90).

You need not make every letter of a title a prominent one; perhaps use only the initial letter or the first letter of each word. You can also pick out other capital letters within a piece of text for enlargement and illumination (Fig. 91).

Illustrations

Sketches of the illustrations should be added to the rough along with the lettering as these will make a difference to the space available and the sizes required. You will frequently find that the shapes and spaces created by each piece in the composition will suggest further ideas and improvements.

The illustrations to be included should influence your choice of lettering styles. Light watercolour paintings of scenery, flowers or general landscapes require small, delicate lettering, whereas bolder, solidly painted objects or illustrations such as company logos, badges or coats of arms can be accompanied by larger, stronger lettering styles.

(Fig. 91) Picking out letters within the text

Colours

You can write with the colours you intend to use so that you can check that these will go well together. Trial and error is necessary when choosing a balanced mixture of colours. Sometimes paler colours recede too much, light blue in particular tends to look rather wishy-washy in comparison with other colours. Red and black on the other hand can appear very prominent. Lemon yellows and other light transparent colours will be difficult to see on pale backgrounds; darker, opaque colours such as yellow ochre are better.

If you have a large block of unbroken text you can liven it up by picking out certain words in another colour. Sort through the text and underline any words that are more important than the rest, for example:

> *King Edward* ravaged all *Northumbria* because they had taken *Eric* for their king. It was in that ravaging that the minster at *Ripon*, built by *St. Wilferth*, was burnt down. When the king was going homewards, the force in *York* overcame the king's troops left behind in *Castleford*, and there was much slaughter. The king was then so enraged that he wanted to turn back and destroy that land and everything in it.

These can then be highlighted with a different colour. A sprinkling of colour through a plain black text can be very attractive.

Decoration

Floral decoration is frequently useful to fill up unwanted gaps, especially at corners. Fig. 92 shows one of a series of cards recording peals of bells, where this method was used. Borders in varying shapes can be included and it is often possible to make up a border with objects relevant to the text rather than with just a foliage pattern. Fig. 93 shows narrow strips of border designed to include items mentioned in the manuscript.

Work Order

The work order of the piece shown in Pl. 6 was as follows. The general layout was first sorted out (see design (ii) in Fig. 86), and it was decided that five different sizes or styles of lettering were needed for the text. The long columns of small text were dealt with first as it was necessary to ascertain how long the columns would be and whether they would enable the piece to have the proportions wished for. A size 4 nib was tried first and a dozen or so words written out, but it soon became apparent

(Fig. 92) Decorative card, size 6 x 8 inches

that this size of text would occupy far too much room and make the whole piece much larger than originally intended. The procedure was repeated with a size 5 nib and the results were a great deal better. A few lines were tried with a size 6 nib to see if this would be better still. The lettering in this size worked just

(Fig. 93) Illustrative border designs

as well but I decided to stick to the size 5 lettering as it would be a little easier to read.

Having settled on the lettering size, the whole of the longest column of text was written out so that the maximum amount of space needed for this part of the piece would be ascertained. This piece of text was then cut out and attached to the layout sheet. Roughly calculated pieces representing the other two columns were added.

Next, each of the sub-headings was written. I knew from the previous trial of the size 4 nib that this would be a good size for this text. These pieces of lettering were placed on the rough, then the column titles were written in versal letters. The original height chosen for the titles proved too large for the whole of the longest word to fit within the column width, and since I did not want it to overlap the edges, the size was reduced to accommodate the whole word. With that in position the other two titles were added and all looked well. However, as I had

(Fig. 94) Rough layout of text for piece in Plate 6

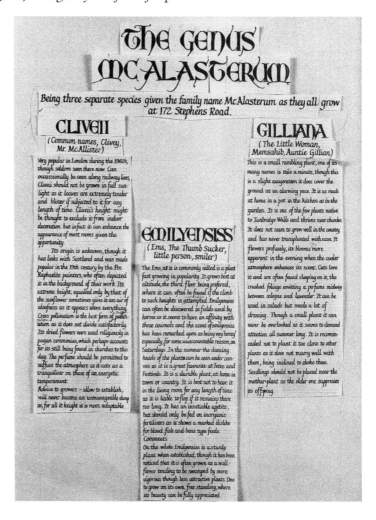

needed to make the titles a little smaller than intended I decided to use the size 6 nib for the lettering in the columns after all. This did not make a great deal of difference to the proportions as I kept the width of each column the same and the letters were only very slightly smaller, but it gave a lighter, more delicate feel to the large blocks of text, which was a definite improvement. The overall title was treated in a similar manner to the smaller column titles, and a suitable size was found (Fig. 94).

Small sketches of the plant illustrations were added to the spaces ready for them. The space available for the illustration in the third column was clearly going to be too much, and as I did not want to alter the sequence of the columns of text the only solution seemed to be to elongate the column by allowing more space between the lines of writing. I wrote out the whole column with this new spacing and placed it on the rough. It did not appear unbalanced and seemed a good solution. The remaining column was written out in the original line spacing,

(Fig 95) *Complete rough layout for piece in Plate 6*

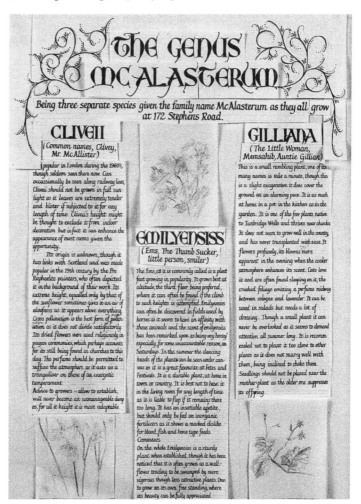

to make absolutely sure the whole piece would look right and to check that the number 6 nib would not significantly alter the rest of the design. The colours chosen were all natural plant-like colours: brown, dark green, yellow ochre and sage green.

As there was a large amount of space around the title the whole piece seemed a bit bottom-heavy, so I tried adding some extra embellishment. After trying several alternatives, a swirling pattern of stylized floral stems seemed the most suitable. The pencilled outline of this pattern was written over with a pen in a suitable colour to check the directions that would be needed to make the strokes and also to see that it would still look right when the illustration was bolder and in its intended colour. A few touches of gold were added here and there to brighten the piece; the rough was now complete (Fig. 95).

Choosing Paper

There are so many interesting colours and textures of paper available in art shops these days that you are sure to find something suitable for any piece of work. Some very interesting papers available from specialist shops are discussed in Chapter 9. It is better not to have anything too garish for an elaborate piece of work, just something to add a little more interest to the piece. It is also important when using a paper for the first time to make sure that it will take ink suitably. If the paper is too porous the ink will spread, if too resistant the ink will remain

(Fig. 96) A Heraldic chart, size approx. 18"x24" (458x610mm)

wet on the surface for a long time and be in danger of smudging and also of flaking when dry. Beware too of papers with inconsistencies. Some papers will have thinner patches or greasy spots that will spoil the lettering.

For *Genus McAlasterum* the piece in Pl. 6, I wanted something with a suitable horticultural feel and therefore used some cream-coloured paper with a flecked fibre look, the flecks being a greenish grey.

For this type of work it is always a good idea to cut the paper larger than you need it then trim it down afterwards. When you are working on something for a long time the corners are prone to becoming dog-eared or snagged when it is picked up and put down. With larger paper you can also decide to have larger margins if you think they will look better. Use a well-sharpened B pencil to rule in the writing lines as it will ensure that they are accurate and can be easily removed afterwards. Try not to touch the paper with your hands too much. You would be surprised at the difference between a clean sheet and one that has had hands rubbed over it several times.

For the sample piece I wrote the columns first, then added each successive piece of text in the same order as for the rough, with the title added last. The pattern around the title was pencilled on first, then written over with ink. The small gold touches were added with a brush and burnished. The illustrations were sketched in lightly and brush-painted using Designer's Gouache. The finished piece was then trimmed and ready for framing.

A more complex piece with a greater amount of illumination but requiring basically the same procedure is shown in Fig. 96. As the illustrations were more complex they were drawn accurately on layout paper and then traced on to the work. Unless you can draw the illustration on with ease it is better to do this, as a lot of rubbing out will spoil the paper surface.

7 Maps

Beautifully written and illustrated maps have been made for centuries, combining useful information with artistic interest. The degree of correctness and usefulness has fluctuated greatly according to the knowledge available and fashions of the time. Obviously the older maps of the early Middle Ages tended to be comparatively inaccurate and were more often picturesque to relay information to those who could not read. Gradually a need for more accurate maps was established as new lands were discovered and travel became more widespread, and they became more precise and factual. Detailed charts showing the grounds of large estates were also often to be found in great houses.

A decorative map makes an interesting and enjoyable project, combining as it does artistic and geographical skills. It is a good idea to start with correctly scaled maps of the area you intend to depict (if they are available) as, although a certain amount of artistic licence is allowed, it is pointless making your work too inaccurate. You will need to spend some time researching the area you have chosen and sorting out what illustrations (if any) to use, which places you want to show and which can be omitted, and any other decoration required.

Scale

With a map of a large area you will need to decide on the scale. Make an outline or rough sketch of the *whole* area on layout paper. It is important to do this as you can easily be misled by the scale of only a section of your map and end up with something much larger than intended. Mark dots for the start of each place-name so that you will know where it should be written in (Fig. 97). Next sort out the part of the map that is likely to be the most congested and use this as a test piece. If the information you wish to include will fit on this area there should be no trouble with the rest.

Fig. 98 shows the trial area experimented with for the map in

(Fig. 97) Map outline and indicator dots

Pl. 7. This area was so much more crowded than the rest that it was imperative to make sure all the information would fit. As rivers were to be indicated these were sketched in on the rough layout so that their names could be accurately positioned. The smallest nib size (a no. 6 William Mitchell 'Roundhand') was used and the names were written on to a piece of tracing paper over the rough layout, keeping each as close as possible to it's indicator dot. At first it seemed as if there wouldn't be room for all the names, but after taking a second sheet of tracing paper

(Fig. 98) Trial area of lettering for Plate 7

and re-writing them it was possible to manoeuvre the names slightly so that they would all fit and be close enough to their indicators to tell which place corresponded with which dot. If you create a map where the areas or places named are far apart it isn't necessary to use indicating dots, but on a map with closely grouped names it is the only way to indicate accurately. While the place-names for my map project had to be accurately positioned, there was more room to manoeuvre the river names which could be placed anywhere along the rivers' length. Similarly the county names could also be positioned in any vacant space within the relevant area.

The rough work for a map of the English counties in Fig. 99 was carried out in a slightly different manner. Many little illustrations for each county were required and each had to be carefully fitted into its county boundary along with the required lettering. As the map was made purely as a decorative display

*(**Fig. 99**) Rough layout for a map of the English counties*

Montguyon

Dordogne

Aquitaine

(Fig. 100) *Lettering sizes and styles used for Plate 7*

poster the words and illustrations were adapted to fit into the available space rather than adjusting the space to fit the lettering.

Different sizes, styles and colours of lettering can be used for each type of area or landmark. For example the three subjects named in the map in Pl. 7 — counties, towns and rivers — were differentiated in the following way: the towns being the largest group, were written in the smallest size and in black Compressed Foundation Hand; the counties were in a larger size and in red; the rivers were written in blue Italic (Fig. 100). These colours were chosen to correspond with the principal colours used for illustrations.

Flourished Capitals

When a short name indicates a large area you can stretch the word or words out across the map with large flourished italic letters. Some other lettering styles also lend themselves to this sort of treatment, but italic works most successfully. The capitals in particular have strokes that can be lengthened and embellished (Fig. 101).

Water and Coastlines

There are various ways of showing sea or coastline. The sea can be totally covered with a solid colour, or a graduation of tone from light to dark can be used (Fig. 102). Type (a) is achieved with blended-in washes of several shades of blue gouache paint. Type (b) has rings of solid colour, which gives a bolder effect more suited to some pieces. The lighter, softer effect (c) uses coloured pencils (Cumberland 'Derwent' series) shaded from light to dark. The colours will not fade even after several years when some gouache colours will have lost a little of their original brilliance.

For the speckled effect (d), gouache paint was 'sprayed' on with a toothbrush. Paint spray diffusers or airbrushes can be used but a toothbrush, although messier, will give a nice variation of texture as the specks come out in different shapes and sizes.

For this method it is necessary to *mask off* the areas where the paint is not required. For this you will need masking fluid (available from art shops), plenty of scrap paper, masking tape and several small paintbrushes for painting on the masking fluid (old

Aa Bb Cc Dd

Ee Ff Gg Hh Ii

Jj Kk Ll Mm

Nn Oo Pp Qq

Rr Ss Tt Uu Vv

Ww Xx Yy Zz

(Fig. 101) *Flourished Italic letters*

(Fig. 102) Coastline effects

paintbrushes will do fine). Carefully paint the masking fluid around the outline, taking it to about an inch wide or further if there are awkward bits not easily covered over with sheets of paper (Fig. 103). The masking fluid very quickly clogs up a brush as it dries and is difficult to remove, so it is easier just to discard one brush and use another. When the outline is done and the masking fluid dry, cover over the rest of the area not requiring paint with scrap paper, taping it down wherever possible. Be careful not to leave any gaps under which paint can sneak — when spraying you will find paint can creep into every uncovered nook and cranny and spoil the accuracy of the edges.

With the masking off complete you can mix your paint ready for spraying. More than one colour can be used to give interesting effects. Spraying can take up a lot of paint so make sure you have plenty of the required colour mixed. The toothbrush is then dipped into the paint. Don't take too much or it will drip on to the piece. Using your finger stroke the bristles back to direct a spray out on to the surface. Make sure

(**Fig. 103**) *Masking areas for the paint spraying*

to experiment first on scrap paper until you are used to controlling the amount of spray. Each time the brush if refilled the first specks produced are larger; as the paint is used up they get smaller. Also keep an eye on the finger doing the brushing as drops of paint will build up and drip on to the work if you are not careful. Gradually build up the layers of speckling from thin to thick in different areas as required.

In Pl. 7 the spray was always directed outwards from the coastline so that the thickest parts were nearest the outline, making it more defined. If you do accidentally get a large drop of paint where you don't want it wait until it dries, then remove it carefully so as not to smudge the surrounding area.

When you have finished the whole area and the paint has dried you can remove the scrap paper and peel off the masking fluid. This is great fun to pull away and gradually a well-defined edge will be revealed, provided you have painted up to it thickly enough. There are likely to be lots of dried spots of paint flying off as you pull the masking fluid away, so dust these off carefully when you have finished. Any parts of the outline that still show can be rubbed out. The lakes in Pl. 7 were given this same treatment individually then the rivers were traced on and painted in with a small fine brush. This method can also be used to cover large land areas, to convey the appearance of grass.

Borders

Sometimes a map will look better for being finished off with a border rather than just fading away at the edges. Simple calligraphic borders can be very effective, or if the map is rich in colour and illustrations something more elaborate can be used (Fig. 104). For the map in Pl. 7 a narrow border was required as the rest of the design was going to be quite light and needed finishing off but not with anything too heavy. Several designs were tried and the most suitable chosen. Example (a) in Fig. 104 was the original choice but as the piece progressed it became apparent that this would be too heavy and detract from the main part of the work, so a simpler one was used instead.

Illustrations

Where a lot of pictorial illustrations are going to be used you need to plan very carefully where the lettering will go so that the two will not coincide too often. Writing over painted areas doesn't generally work very well as the ink tends to spread, and if the layer of paint underneath is thick the ink might disturb it. It is better to plan your work so that you can do all the lettering first, then add the illustrations afterwards.

Simple line drawings with a few watercolour washes added are the easiest type of illustrations to use (Fig. 105). Start with simple sketches that can be added to the rough and adapted to

a

(Fig. 104) Borders for maps

(Fig. 105) Simple line drawings
with watercolour washes

(Fig. 106) Illustration painted in
gouache

(Fig. 107) Watercolour illustrations

(Fig. 108) *Illustrations using*
'Artistcolor'

the spaces available. Towns can be shown with miscellaneous groups of buildings, their quantity varied to give an indication of each town's relative size. If the scale permits, particularly well-known buildings and landmarks can be shown to make places more recognizable.

Little detailed paintings can be added such as that in Fig. 106, which was painted in gouache colours. The illustrations in Fig. 107 were painted in watercolours, while those in Fig. 108 used a relatively new type of colour for artists, Rotring 'Artistcolor'. 'Artistcolor' is purchased in liquid form in bottles and is used in the same way as watercolours. The colours are very vibrant, producing attractive pictures.

The coats of arms required on Pl. 7 were made by copying originals. There were suitable spaces for them on the right-hand side of the map where there were no place-names, and when suitable sizes had been determined by placing sketches in different sizes on the rough, the coats of arms were carefully drawn on layout paper ready to be transferred to the work. It was necessary to scale up the drawings from the photographs supplied. This was done with a mixture of measuring the original, multiplying up the amounts, transferring them to the drawing and judging by eye. The completed drawings on layout paper would be transferred to the piece later.

When all components of the map have been put together, the sketches replaced with accurate drawings and all the effects experimented with and decided upon, you can proceed to the finished piece.

The Finished Piece

If your map or any piece of work is very large, sheets of paper suitable for calligraphy come as large as 28 x 40 inches, available from specialist paper shops. Long rolls of paper can also be purchased; one of the best types is 'Canson Mi Teintes' available in 10-metre rolls at 1.5 metres (59 inches) wide. It comes in a wide range of colours and is fairly thick (160 gsm) with a nice texture.

As always, cut your paper larger than required so that the edges can be trimmed later. Trace down the outlines of the area and the reference points (if necessary) for the place-names. Draw in the writing lines as faintly as possible with a sharp pencil, so that there will be no trace left later when they are removed.

Do all the lettering first, working from top to bottom and left to right so as not to smudge any recently written lettering. When it is completely dry the writing lines can be rubbed out. If you have used paint rather than ink, be careful not to smudge the letters as you erase; rubbing around the words as much as possible rather than over them. Some colours are more prone to smudging than others — red in particular. A few drops of gum arabic can be added to the paint when it is mixed to prevent smudging, but even then you must be careful as paint with too much gum added will become shiny if rubbed, as if it had been burnished.

If there is to be any gold on the work this must be painted on and burnished before other areas around it are painted. The landscape features, such as coastal outlines, rivers, county boundaries, roads, etc. can be added next, then more detailed features and pictures traced into place and painted. Finally, finish off the work with a border if required and trim the edges.

8 Celtic Art

Illumination and decoration used in other countries and by other cultures can be a great source of inspiration for your work. This book would not be complete without reference to the illuminated manuscripts of the Celts. Celtic art is rich and colourful and can be adapted and modernized very successfully.

The word Celtic immediately conjures up thoughts of Ireland, but the type of illumination we associate with the Celts was also prevalent in the north of England, parts of Scotland and Wales. The period in which this artform reached its peak was from the 6th to 8th centuries. The delicate interlaced patterns and highly stylized animals are very distinctive; the scripts associated with them are *Uncials*. The uncial style of writing was borrowed from the Romans (the word *uncia* is latin for inch — referring to the height of the letters). The incredibly complex pieces of interwoven pattern often occupying whole pages in manuscript books were totally Celtic in origin, and this type of decoration can also be found carved on stone crosses and on intricately worked pieces of jewellery.

The designs created in manuscript books were rich in both gold leaf and colour. Both flat and raised gold were used, with reds and greens being the predominant colours. The carefully woven knotwork patterns were very often one continuous line, thought to represent eternity. As was usually the case with early decorated books, they were religious in nature and the patterns of some designs are so complex that parts of their intricate construction are scarcely visible to the human eye, putting forward the belief that the works were done for the eyes of God only, who would be able to detect all errors. Some manuscripts, however, did contain more obvious errors and future generations often made corrections and alterations. The original craftsmen often copied texts from other scribes and could not always actually read or understand what they were writing; sometimes the mistakes were nothing more than carelessness. The degree of accuracy and skill varies greatly even within a single book where several scribes contributed to the contents.

As well as the familiar knotwork panels, spiral patterns were used in profusion, again following carefully constructed grids.

Animals, birds and figures were incorporated into the latticework of borders and made to spring out of the ends of illuminated letters, the letters themselves becoming the body of some strangely contorted animal. This stylization of creatures is very distinctive yet blends in well with the regular patterns.

It takes some time to pick out all the detail in some of the more complex illuminated works and even longer to be able to sort out and form them yourself. The most well known of these, the *Books of Kells*, thought to have been made during the late eighth century possibly on the monastery island of Iona in Scotland, contains many pages of extremely elaborate illuminated letters. Much of this work is made up of spiral patterns interspersed with knotwork. The *Book of Kells* was one in a long line of richly illuminated gospels known as *Insular Manuscripts*. The term 'insular' is used here in reference to the isolated nature of the islands of Britain and Ireland where this type of art was found.

This chapter shows how to construct various patterns and scripts based on historical examples from books such as these. At first glance the designs might seem quite complex, but they are really very simple to construct if the correct procedure is followed. Each one is carefully built up from a starting grid of measured distances.

Knotwork

Single-row Patterns
Begin by marking off a row of equidistant points as shown below (Fig. 109-a).

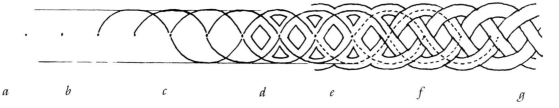

a *b* *c* *d* *e* *f* *g*

(Fig. 109) Single-row pattern

Rule in faint lines on either side (b) then join up the dots with arches (c) making sure that every arch misses one point each time. These lines are your guidelines for the whole pattern. Next draw in the shapes made by the crossing lines (d). This must be done with care since badly made shapes will spoil the evenness of the knots. Draw the outline around the whole row (e). Now interlace the lines under and cover each other (f) making sure

each 'under' is followed by an 'over' otherwise the pattern will be spoilt. Finally, rub out the initial guidelines (g).

This basic pattern can be developed further by breaking the path of a line and turning it another way, but always remember to rejoin it to its own or another broken line so that no loose ends are left.

(Fig. 110) *Elaborating on a basic pattern*

(Fig. 111) *Corners*

The guidelines have been left in as dotted lines on the above patterns (Fig. 110) to show their construction. Notice where additional guidelines have been added to break the original direction and change the effect. These two pieces have been given a finished end that is fairly simple to achieve, and enables you to put a neatly finished strip of border on a piece of lettering. It is often more desirable, however, to have a continuous border surrounding the text and this involves the use of corners.

Corners

Corners can be quite awkward to construct. If you simply continue the line of points down at right angles to the first and take the pattern round the result will be as in Fig. 111a, which has a rather stretched-out, loose effect. It is therefore necessary to adjust the initial points to overlap slightly (Fig. 111b) and continue the guidelines around the corner as shown. Many patterns require this sort of adjustment at corners, and gradually you will get to know how much is needed.

Double-row Patterns

Double rows of starting points make more complex patterns than single rows, but the procedure to follow is identical (Fig. 112).

(Fig. 112) Double-row pattern

Again, numerous variations can be made once the basic idea has been grasped. In Fig. 113 the line has been split and interlaced further at various points. Provided you follow the rule of passing a line over and under alternately the pattern will always work out correctly.

(Fig. 113) Double-row border with split and interlaced lines

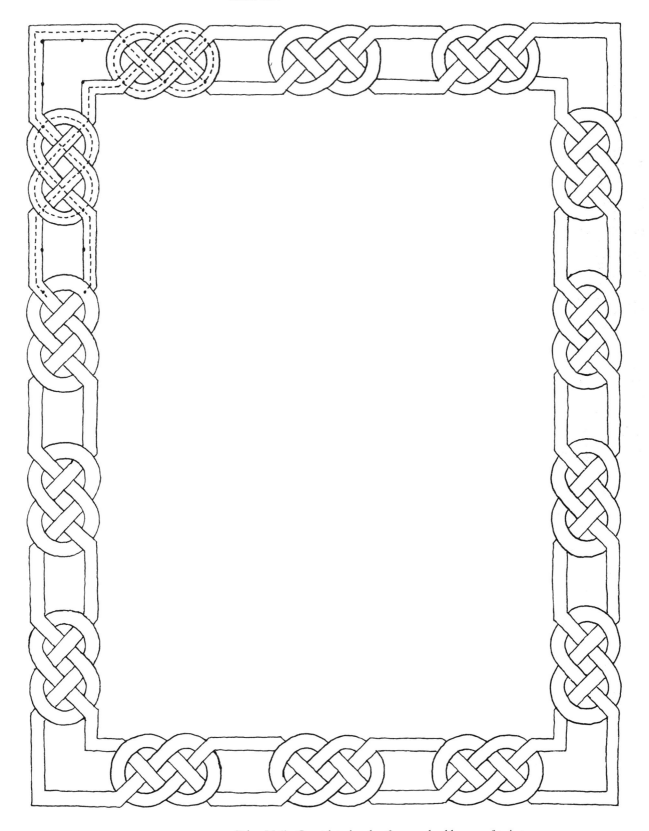

(**Fig. 114**) *Complete border from a double row of points*

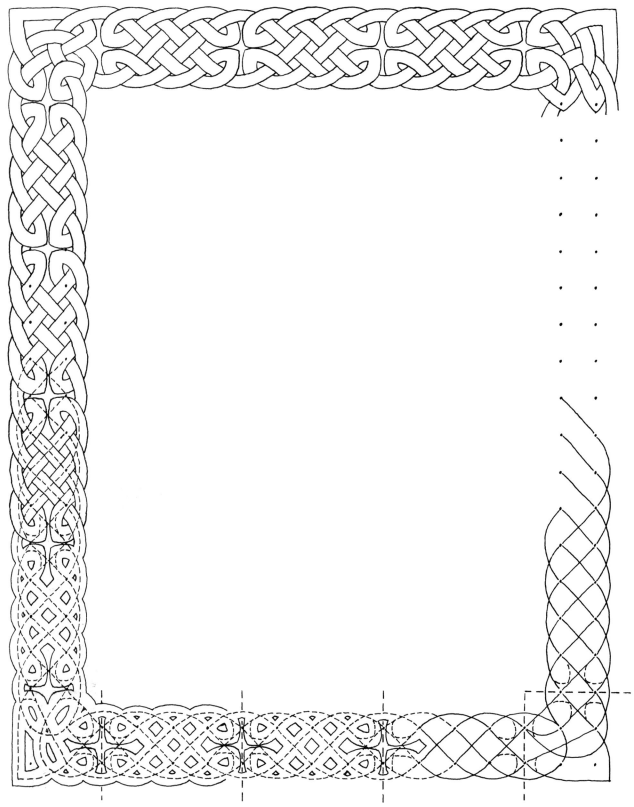

(Fig. 115) Building up a complete border with repetitions of a
pattern

Figs. 114 and 115 show complete borders in patterns derived from double rows of points, with some guidelines left to show their construction. As you can see, each is made up by the repetition of one section. When making complete borders you must be sure to work the pattern out carefully so that there are an even number of repetitions in the knotwork enabling the ends to meet up and the design to be continuous. Of course you need not repeat the pattern exactly each time — you can vary the border with different sections but remember still to plan the whole piece so that the ends will meet up.

Circular Borders
Knotwork circles can be made using the methods already described. Fig. 116 shows how a straight knotwork border can be carried out in a continuous circle.

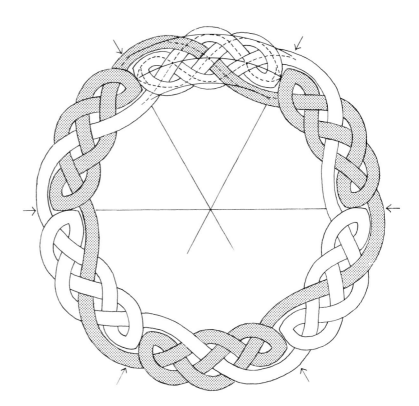

(Fig. 116) Making a circular border

To begin with, draw a circle with compasses, then mark off as many equal divisions around the circumference as you wish to have repetitions of the basic pattern (this is shown by the arrows marking the start of each repetition). Each of these portions is further divided into 4 equal parts. Now you have your row of points from which to draw the guidelines just as you would for a straight piece. When you have worked the pattern around the whole circle you will find that the ends will join up. If you chose to divide the circle into an even number of parts you will have made a pattern of two continuous intertwined lines (Fig. 116). If the original number of sections was odd the pattern will be composed of a single knotted line (Fig. 117). This is useful to know if you wish, for instance, to incorporate two different colours in the design, one for each interlaced line.

Panels and Corner Motifs
Individual pieces of knotwork can be useful as corner decoration on a piece of work or for filling in gaps and breaking up large areas of text. Figs 118 and 119 show two simple pieces of knotwork constructed as before with the initial framework of lines shown for guidance. Pieces as large or small as you wish

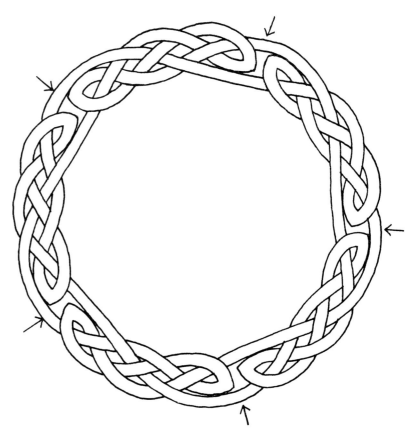

(Fig. 117) Circular border forming a single knotted line

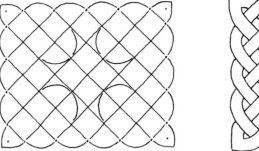

(Fig. 118) Simple knotwork

(Fig. 119)

can be constructed to fill up any space; irregular areas can be filled by carefully working the pattern into the required shape.

Spirals

Spiral patterns were used as frequently as knotwork in Celtic art, and often the two were combined. The basic patterns are composed of one, two, three or more coils as shown in Fig. 120,

(Fig. 120) Basic spiral patterns

and these are adapted in a variety of ways to form interconnecting designs. Fig. 121 shows some variations to the centres and how they can be linked together in either clumps to fill spaces or lines to make borders or added to knotwork as corners. When covering a large area with spiral patterns, work out the construction of the piece roughly with circles (Fig. 122) then gradually work in the detail around this framework.

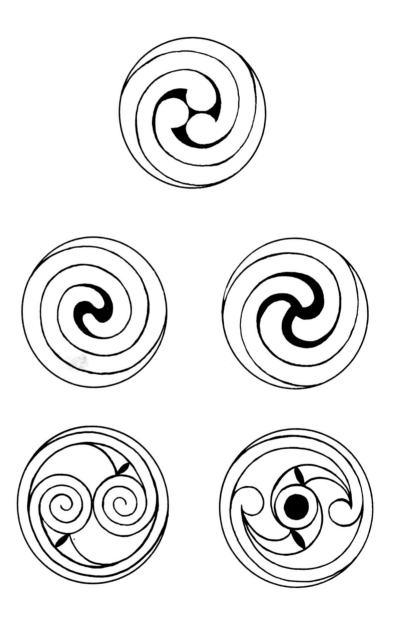

(Fig. 121) Varying the centres and linking groups together

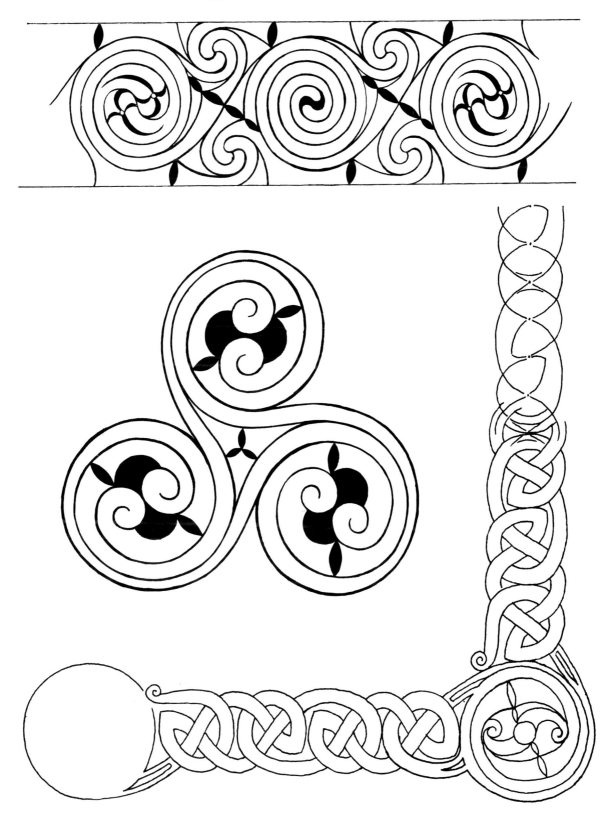

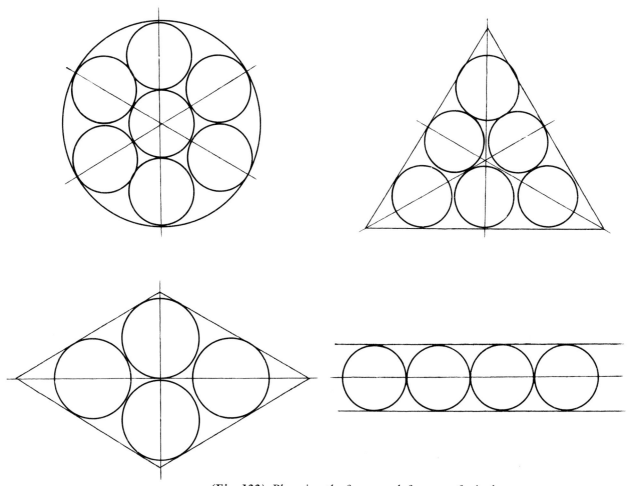

(Fig. 122) Planning the framework for a set of spirals

Once you have the basic idea of how the spirals are linked and the patterns inside and between them constructed, you can form your own quite easily. If you want more ideas before working out your own designs you will find a wealth of examples in Celtic manuscripts such as the *Book of Durrow*, the *Lindisfarne Gospels*, the *Book of St Chad* and the *Book of Kells*. There are many books available now with colour pictures of the best pages in these manuscripts, although many books on illuminated manuscripts neglect these earlier medieval works in favour of the later, more florid styles of other parts of Europe.

Before we go on to the lettering that accompanies this type of illumination, there is another type of pattern that must not be overlooked.

Key Patterns

These are basically interlocking repeating patterns worked out

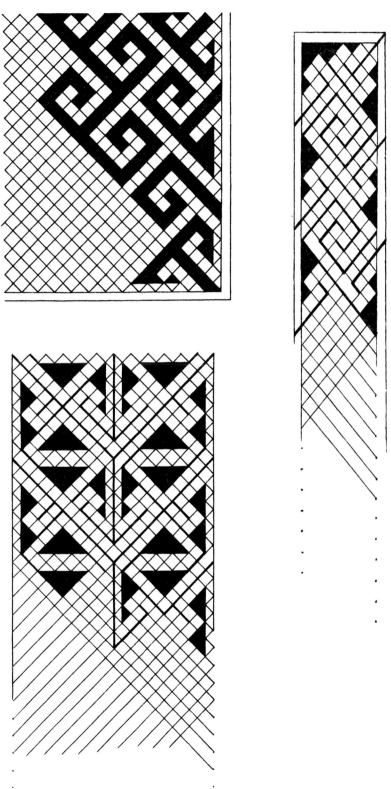

(Fig. 123) Key patterns

on a grid of squares or diamonds. Fig. 123 shows several examples. The pattern can be made to suit any shape by finishing the edges neatly to fit into corners and around curves; it is also useful for filling in areas where more complex decoration would be difficult to do.

Celtic Lettering

The type of letters used in Celtic decoration were very flexible in shape, sometimes to the point of being unrecognizable. Sometimes letters were written with a quill, sometimes they were drawn. They could be fairly simple and unadorned or reach the heights of complex decoration, with a mass of woven pattern, animals, etc. worked into and around a single capital.

To begin with you need to be able to construct the straight-forward letters. The alphabet in Fig. 124 is taken from texts found in the *Book of Kells.* Several letters we now use, such as *K* and *W* were not used at this time, but it is an easy matter to construct suitable forms that fit in with the rest of the alphabet.

abcdefg

hijklmn

opqrstu

vwxyz

(Fig. 124) Uncials taken from the 8th-century Book of Kells

abcdefg
hijklmno
pqrstuv
wxyz

(Fig. 125) Adapted uncials

An adapted alphabet (Fig. 125) is necessary if you want your letters to be more legible, as some of the medieval ones are not easily recognizable.

Fig. 124 is just one set of minuscule letters used in Celtic art; there are many variations on individual letters. You will also frequently find letters joined together or elongated to fill up spaces (Fig. 126).

To form these letters the pen is held at a very flat angle for most of the strokes, but for parts of some of the letters the pen needs to be manipulated in various directions. The height of the writing lines is usually four times the width of the nib. Here some of the letters most likely to give trouble are discussed in greater detail:

(Fig. 126) Elongated letters

The first stroke of the *d* is virtually horizontal, and has an extra stroke to give the letter a thicker start.

The *f* requires a short diagonal stroke before the first vertical and a slight thickening stroke at the base, then one curved and one straight horizontal stroke to finish.

The *g* is the most unrecognizable of the uncials, beginning like the *t* then finishing in an elongated *s* shape.

Make the strokes of the *p* in the order shown, the final one just touching the first vertical.

The *t* begins like the *d* with a thicker piece. Then, after the main curved stroke, an extra stroke is added so that the letter will not seem to overbalance.

The *v* has extra strokes at the top of both diagonals. You also need to make sure that the bottom ends meet together exactly.

ΑΑΛΑΒΒΕͰϹ

DΕΕϜϹͰΙLL

ΜϾΝΗΟ

ΡЧͳͲℝЅϪͳ

ͳUVϢΧϤℨ

(Fig. 127) Some capital letters found on Celtic manuscripts

The *y* is a rather awkward letter, seemingly out of character with the rest. Provided the first long curving stroke is well made, the remaining parts are fairly simple.

Make the middle stroke of the *z* extend below the writing line slightly, then arch the nib back up and round as shown, for the terminating stroke.

Capital letters are subject to even more variation than the minuscules. They were not used at the beginning of each sentence in the way we use capitals today, but were used instead to mark the start of important words or passages, or as headings to pages.

In the original texts you will often find the minuscules enlarged as capitals; you will also find titles made up of very angular letters, others with split and interwoven stems, and some pieces of text that incorporate several different types combined. The success of this random combining depended largely on the skill of the scribe. Sometimes the effect would be pleasing, at others the page would look unbalanced. Fig. 127 shows a selection of capital letters found in manuscripts of this period.

The ampersand (symbol for *and*) was often chosen for illumination, to mark paragraphs and break up the page of text (Fig. 128).

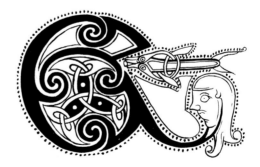

(Fig. 128) Decorated ampersand

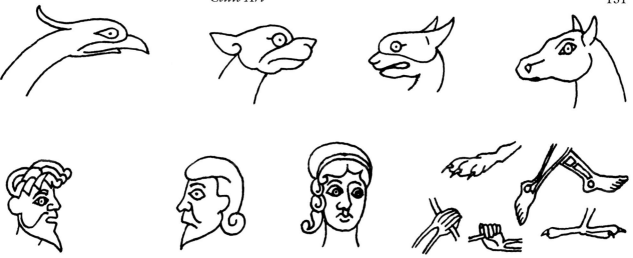

(Fig. 129) *Heads and feet from Celtic designs*

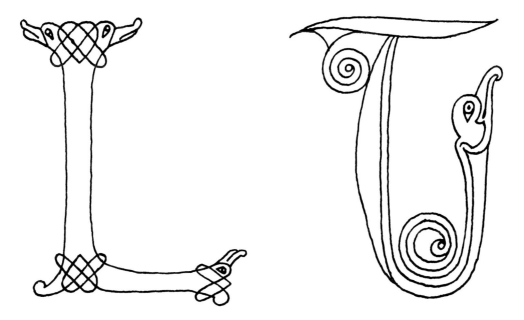

(Fig. 130) *Letters incorporating creatures*

Zoomorphics and Anthropomorphics

The ends of letters were frequently terminated with stylized human figures, animals or birds. Heads and feet (Fig. 129) are often all that need to be added as the bodies are normally rendered as knotwork or parts of a letter (Fig. 130). The representation of animal, bird and reptile forms in Celtic art is known as *Zoomorphics;* representation of human form as *Anthropomorphics*. Fig. 131 shows various patterns incorp-

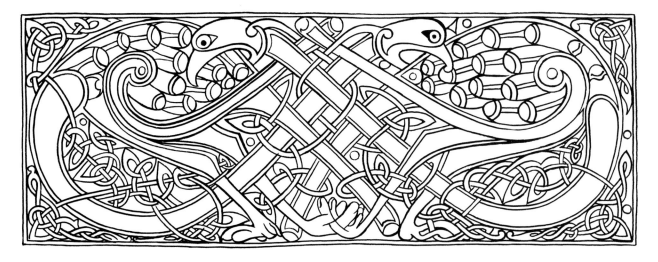

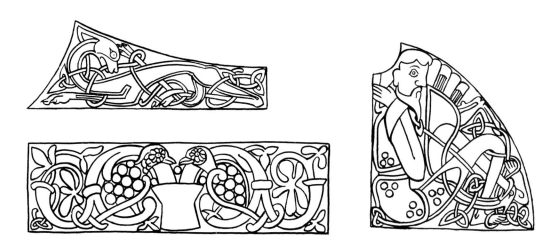

(Fig. 131) Patterns incorporating animals and figures

orating these things. Leaves, fruit, etc. were also incorporated
into Celtic designs, but not to a great extent.

9 Alternative Ideas

This chapter contains a few ideas for adding a little variety and fun to your work.

Writing in Spirals

Learning to write on lines that aren't straight isn't difficult, but you must remember to keep a uniform size and shape to your letters. Circular pieces are easy to do since you can draw accurate guidelines in with a compass. To make a continuous spiral start with a straight line and mark off at equal distances the points where you want your writing lines. Alternate the arches for the circles from one side to the other between the two central points as shown (Fig. 132a). The inside lettering is quite difficult to write as it is tightly curved and the letters have to be distorted so that they are wide at the top and narrow at the bottom, but as you work outwards the effect lessens and the letters can assume their normal character. Alternatively the centre can be filled with some sort of decoration (Fig. 132b).

Wavy Lines

For wavy lines that you cannot make with drawing instruments the best method is to train yourself to write on one line only, so that you can draw a series of base lines to write on but do not need to spend a long time measuring the correct distance for each top line. Any slight discrepancies in letter heights will not be very noticeable on undulating lines of text, but too much unevenness will look unpleasant. The lettering in the lower picture on Pl. 4 was written with bottom guidelines only. The lines were carefully drawn so that each was an attractive curve and at a suitable distance from the others. For the coloured words, the pen had to be cleaned and refilled each time. With

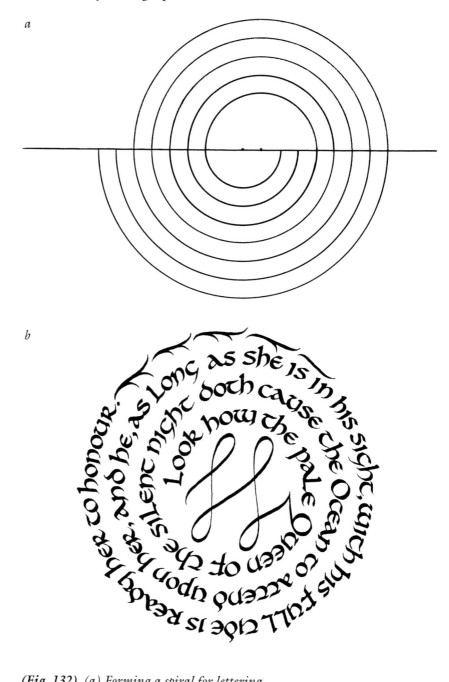

(Fig. 132) (a) Forming a spiral for lettering
 (b) Lettering and centre decoration

large nib sizes you can get away with using separate pens for each colour, but with smaller sizes any slight difference in the nib will show up in the lettering. Sizes 4, 5 and 6 can often vary quite considerably, and I have often bought 6s that are larger than 5s.

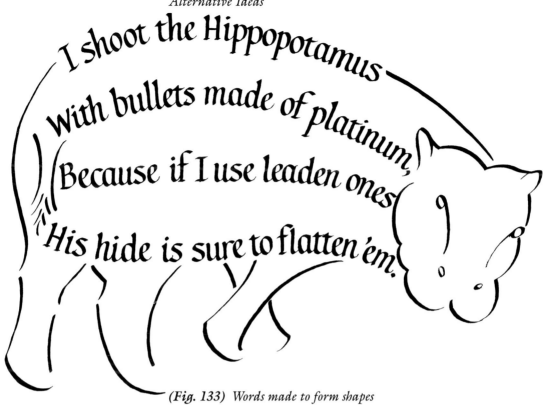

I shoot the Hippopotamus
With bullets made of platinum,
Because if I use leaden ones
His hide is sure to flatten 'em.

(Fig. 133) Words made to form shapes

Shapes

Calligraphy can be used to create pictures by writing around shapes and filling in areas with words. A simple example is shown in Fig. 133; you can build up elaborate and very complex designs with a mixture of different lettering styles and textures.

Music

An interesting project is to write out the words and music to a song. The staves for the notes can be made with a music pen, which draws all five lines at once. The range of sizes these pens come in is rather limited, however, and they can be difficult to find, so if you have a ruling pen it is best to draw the lines accurately yourself. The size of the music notes should be in proportion to the stave and a nib as wide as the distance between each pair of lines is best, so that whether a note is written on a line or in a space it will clearly be seen (Fig. 134).

Music for masses was written and illuminated in medieval manuscript books. All medieval churches were expected to have a *Gradual* and an *Antiphoner* containing all the sung parts of the mass. Fig. 135 shows a rough copy of part of a very large

(Fig. 134) *Notes on lines and spaces*

17th-century *Gradual* from a church in the Spanish colonies of Mexico.

When you have chosen a piece of music, have a look through it and sort out what is and isn't needed. A lot of expression marks can be omitted as they aren't really needed on a piece of this sort and will only clutter the work.

Fitting the words and notes together is important, and since the words generally take up more space than the notes they should be written first on the rough. It is not necessary to use the same size nib for the words and the notes. Draw in a few staves and write out the words underneath. You can break up the syllables with hyphens as they would normally be shown to correspond with the notes.

When you have written a couple of lines go back and add the notes above. You can make them either horizontal or diagonal. The tails of the notes (if you wish to use them) and bar lines can be made either with the pen held vertical or with a brush. If the notes fit reasonably well with the words you can finish the rough off; if not, widen or compress the words or if necessary go to a different size nib so that they will match up.

Gold music notes raised and burnished on black staves can look very attractive, and you can add illuminated initials as you would for ordinary text.

If you have got a music pen you can try using wavy lines which work very well for expressing flowing bars of music (Fig. 136).

Interesting Papers

A good way of introducing some variety into your work is by experimenting with some of the vast array of papers available. Specialist paper shops sell dozens of colours and textures, and even small local art shops are becoming more adventurous with their stock.

The first set of papers in Pl. 8 are standard types that can be used for most pieces in place of cartridge paper. They are tougher, mistakes can be removed more successfully and the laid texture each has is more attractive than the plain surface of cartridge. The first three are shades of 'Fabriano Ingres' paper, available in 90 gsm and 160 gsm. This paper also comes in a wide range of bright colours. The first two sheets are white and cream 'Canson Mi Teintes' paper in 100 gsm and 160 gsm

(Fig. 135) Calligraphic music

(Fig. 136) A 5-line music pen used to make flowing staves

weights. This paper is also available in a large choice of colours and long rolls as described on page 111. The bottom sheet is 'Arches Ingres' paper and is available in large (65 x 100 cm) sheets and several thicknesses.

The second set shows two types of coloured paper and card. The top sheets are 'Marlmarque', a marble-effect smooth-surfaced 90 gsm paper or 200 gsm card. The bottom sheets are 'Parchmarque', the surface of which is available in 90 gsm paper and 176 gsm card. Both of these papers are very widely available, or can be ordered by post from some of the paper shops listed on page 142. The sheets are around 50 cm x 65 cm in size, enabling fairly large pieces of work to be carried out.

In the third set on Pl. 8 we see vellum and parchment skins, along with several types of paper which are would-be substitutes. As you can see, the appearance of vellum, with its natural variations of colour and texture, has not yet been completely duplicated, nor has its smooth velvety surface texture, which is so enjoyable to write on, been recreated. Nevertheless some good substitutes have been made and those shown are, from left to right: Manuscript vellum, Classic vellum, Sheepskin parchment, Pergamenata vegetable parchment in cream (also available in white) — sold in 160 gsm and 230 gsm thicknesses; cream and pale brown Cloud Nine parchment paper (very similar to Parchmarque and also available in several colours) in 190 gsm and 200 gsm thicknesses; Elephanthide in off-white and cream and in two thicknesses, 110 gsm and 190 gsm.

Elephanthide has nothing to do with elephants' skin. It is a very attractive paper with a smooth shiny surface. It can sometimes contain porous patches where ink will spread, or parts which resist ink, but these are usually confined to small areas and can be treated in the same way as similar problems with vellum (see page 89), but as no paper has the durability of vellum the repairs will not always be so unnoticeable. It comes in large sheets, 70 x 100 cm, as do the Pergamenata vegetable parchment sheets. The surface of the latter is a little grainy but very uniform and has the transparent quality associated with real vellum skins.

The papers in the final set on Pl. 8 are all Japanese and can cost as much as £5 a sheet. The Japanese are extremely creative with their papers and even before being worked on they are very decorative. The first is wood veneer and it comes in several neutral colours. The surface is smooth, slightly soft and springy, making it excellent for lettering. The second is Unryu; available in several colours, it has a straw-like effect and is fairly thin. This paper is too fibrous to be written on with a metal nib but brush lettering can be painted on and some lovely effects achieved. The next paper has small coloured fibres mixed into it, paper

number 4 has pieces of gold leaf scattered across its surface. Sheet 5 is a coated and embossed 215 gsm card called *Brillanca*. The sheet shown is *Shantung*, there are others called *Silk* and *Satin*, and all three take ink very well. The final paper has a scattering of threads and small shiny squares. Most of these papers are intended for use on one side only. It is worth visiting paper shops to see what is available before you decide, and they will usually have some new types on display. Some shops will supply sample booklets and lists.

Papers with attractive flecked-fibre surfaces are available, and most local art shops carry a selection of the colours and types available.

Different Writing Instruments

Sets of different nibs can be purchased and can be very useful on occasions. *Poster* nibs come in larger sizes and can be employed for making large capitals, but do make some trial letters with each nib before you use it on a piece as they can sometimes be very blunt and produce rather thick, blotchy letters. All nibs can be sharpened with an Indian oilstone. Stroke the nib across the oilstone several times, then once on the reverse side and quickly on each corner to remove the burr.

Sets of *Scroll* nibs producing a double- or triple-lined stroke are available. The packs contain nibs of different sizes with the points set at various distances apart. They are as simple to use as ordinary nibs once you have got used to making the ink

abcdefghijklmn

opqrstuvwxyz

A smell of burning
fills the startled air.
The Electrician is no
longer there!

(Fig. 137)

(a) Scroll-pen lettering
(b) Effects produced by scroll-pen lettering

(Fig. 138) Quill pens

flow from both points at once (Fig. 137a). The letters produced can be used to express particular effects (Fig. 137b).

Quills are the best writing implements, geese and turkey feathers the most commonly used. The barbs are normally stripped from either side of the barrel so that they will not get in the way when you are writing. The barrel is too soft to write with as it is and is covered with a membrane that must be removed. The barrels are hardened by being heated and the membrane can then be easily scraped away. The pen is then shaped and cut to size.

Ready-made quill pens can be purchased in any size required (Fig. 138) from L. Cornelissen & Son (see list of suppliers on page 142). They are easily spoiled by incorrect use or by applying too much pressure, which softens the ends and blunts and distorts them. When a light, delicate touch is used you will feel and see the difference between the strokes a quill makes in comparison with those made by a metal nib. Thin hairlines are much easier to achieve, and the slight springiness of the nib lends itself to more spontaneous, flowing lettering.

Once the groundwork has been done and the basic techniques described in this book are acquired, the possibilities for creating interesting illuminated pieces are endless. The real pleasure of illumination comes from designing pieces that reflect your own personality, tastes and creativity. These are things that cannot be taught but that everyone has their own hidden store of, waiting only for the right inspiration to draw it out.

List of Suppliers

L. Cornelissen & Son Ltd,
105 Great Russell St,
London WC1B 3RY

gilding materials, gouache, gum arabic, pens, nibs, ink, papers, vellum, brushes, masking fluid, gold and aluminium leaf, pounce and gesso ingredients, burnishers, quills, scalpels, drawing boards

Winsor & Newton,
Whitefriars Ave., Wealdstone,
Harrow, Middx HA3 5RH

Designer's Gouache, brushes

Rexel Art & Leisure Products,
Gatehouse Road, Aylesbury,
Bucks HP19 3DT

William Mitchell Pens

Rotring U.K.,
Building One, GEC Estate,
Wembley, Middx HA8 7DY

'Artistcolor', drawing instruments

E. S. Perry Ltd,
Osmiroid Works, Gosport,
Hampshire LS16 0AL

Osmiroid pens and nibs

Mail Order

The Duchy Gilding Co.,
The Old Mortuary Studio,
Gyllyng Street, Falmouth,
Cornwall

gilding materials, vellum, parchment

Falkiner Fine Papers Ltd,
76 Southampton Row, London
WC1B 4AR

papers, vellum, gilding materials, nibs, pens, ink

William Cowley,
Parchment Works, 97 Caldecot
Street, Newport Pagnell, Bucks
MK16 0DB

parchment and vellum

George M. Whiley Ltd,
Firth Road Houston Industrial
Estate, Livingston, West
Lothian, Scotland EH54 5DJ

gold and aluminium leaf, transfer leaf, gold, powder, burnishers.

Index

aluminium leaf 80
ampersand, Celtic 130
animals 48, 49, 50
anthropomorphics 131
applying gold 62

Blackletter
 minuscules 57, 59
 majuscules 60, 61
borders
 painted 36
 pen-drawn 24
buildings 50–51
burnishers 62

capitals
 Blackletter 60
 Celtic 129
 compressed Foundation 15–16
 flourished italic 105
 versals 30
Celtic art 113–4
Chinese stick ink 11
circular borders 119–20
clothing 48
coastlines 105, 107
colours 96
corner motifs 116, 120
costume 48

decoration 24, 96
diaper
 embossed 56
 floral 52–3
 geometric 54–5
 Persian 56–7
 repeating patterns 56
double-row Celtic borders 116, 119
drawing board 11

embossed diaper 56
errors 17–23
 erasing 89–90

fabric 81–90
faces 49, 50
figures 48, 50
filigree pen-work 33–35
floral diaper 52–3
flourished capitals 105
Foundation Hand 12–23

geometric diaper 54–5
gesso 68–71, 73–4
gilding 62, 74
glass 71
gold
 loose leaf 67
 powder 63–4
 transfer leaf 65
gouache paint 11
grotesques 50

hair 50
hairlines 49
hands 13, 49, 50
headgear 48, 49
historiated initials 45, 46, 61

illustrations 95, 109
initial letters 24, 26, 39
ink 9

key patterns 126–30
knotwork 114–6

layout 91
lettering
 blackletter 57
 Celtic 126
 Foundation Hand 15–23
 uncials 113, 126–30
 versals 30
line fillers 57
line-height chart 16

maps 102
 borders 109
 scale 102–4
margins 31–3
masking fluid 105
music 135–6

nibs 9–10
nib sizes 9–10, 16, 96–100

painted borders 36–8
panels, Celtic 120
paper 9, 11, 100, 136–40
parchment 81, 89
pen-drawn borders 24–41
pens 9
Persian diaper 56–7

perspective
 buildings 50–1
 diaper 52–7
posture 11
pounce 88
problem areas
 gilding 77–80
 vellum 89–90

quills 141

raised gilding 68–9
repeating-pattern diaper 56
ribbon scrolls 95
roundhand 15

scroll pens 140
scroll-work headings 95, 140
serifs 22
shapes, writing in 135
single row Celtic patterns 114–5
slaked plaster 69–71
spacing 19
spirals
 Celtic 121
 writing in 133
spray diffuser 105–8
stick ink 112
surroundings 50

titles 95
transfer leaf 65–6
transfer/tracing down paper 66, 103–4
trees 51
trial sketches 92–3

uncials 113, 126–30

vellum 81
 stretching 82–3
versals 25, 30

water and coastlines 105, 107–8
wavy lines 133–4
wood 82–8
work order 96, 98–9
writing instruments 140–1

X-height chart 16

zoomorphics 131

T. N. Lawrence & Son Ltd,
119 Clerkenwell Road,
London EC1R 5BY

papers, brushes,ink

Craft Creations Ltd,
1–4 Harpers Yard, Ruskin Road,
Tottenham, London N17 8NE

papers

Frisk Graphic Art Materials,
4 Franthorne Way, Randlesdown
Road, London SE6 3BT

Transtrace wax-free pure
graphite tracing down paper

Australia

Will's Quills
164 Victoria Avenue,
Chatswood NSW 2067

Oxford Art Supplies,
221-223 Oxford Street,
Darlinghurst NSW 2010

Le Grafic,
247 Pacific Highway, North
Sydney NSW 2060

Calligrafic Arts,
15 Harlock Street,
Preston QLD

The Calligraphy Centre,
Shop 59, Myer Centre,
Elizabeth Street,
Brisbane QLD

Calligraphy Centre,
960 Whitehorse Road,
Box Hill VIC

U.S.A.

Pendragon
862 Fairmount Avenue, St Paul,
MN 55105

all calligraphy and illumination
materials

The Society of Scribes
PO Box 933, New York,
NY 10022

Friends of Calligraphy
PO Box 5194, San Francisco,
CA 94101